Sleeping Trees

Scrooge and
The Seven Dwarves

First publishedander Street, Ltd
(info@salaman... ...

Child of the ...
Scrooge and
All rights reserve...

Salamander Street

PLAYS

First published in 2019 by Salamander Street Ltd.
(info@salamanderstreet.com)

Cinderella and the Beanstalk © Sleeping Trees, 2014
Scrooge and the Seven Dwarves © Sleeping Trees, 2016

Printed and bound in the United Kingdom

10 9 8 7 6 5 4 3 2 1

FOREWORD

These shows were originally (and tirelessly) performed by a cast of three, but they can be adapted and performed by any number of people! As with all good pantomimes, all of the gender roles can be reversed and there is no set age for any of the characters, just get stuck in and have as much fun with them as we did.

Trees x

SCROOGE AND THE SEVEN DWARVES

Scrooge and the Seven Dwarves was co-produced by and first performed at Theatre503 Christmas 2016.

Writers:	John Woodburn, James Dunnell Smith, Joshua George Smith
Director:	Simon Evans
Musical Director and Composer:	Ben Hales
Movement Director:	Oliver Kaderbhai
Performers:	John Woodburn, James Dunnell Smith, Joshua George Smith, Ben Hales
Producer:	Alice Carter
Set and Costume Designer:	Zahra Mansouri
Lighting Designer:	Jai Morjaria
Production Manager:	Rich Irvine
Stage Manager:	Holly Ellis

THE SAME OLD MISTAKES

Christmas carols are playing as the audience enter. Once the house lights are down **JAMES**, **JOHN** *and* **JOSH** *of the Sleeping Trees enter from the top of the theatre dressed in tuxedos.*

JAMES: Good evening ladies and gentleman, boys and girls, how are you doing this evening, are you well?!

> *The audience cheers.*

Fantastic, well my name is James

JOSH: My name is Josh

JOHN: And my name is John

JAMES: And we are thrilled to be back guys and what a pantomime we have written for you this year. We have an unbelievable set hiding behind this curtain here, we've got loads of pantomime characters, fairytale characters –

JOSH: – There's a giant lobster. That's my favourite bit.

JAMES: Yes there is a giant lobster, that's right and we've even got the best impression of a Christmas tree by a person in the front row.

> **JAMES** *picks on an audience member.*

I believe that was you there. Would you mind standing up and showing everyone your famous Christmas tree impression.

> *Audience member gives their impression.*

> **JAMES**, **JOSH** *and* **JOHN** *erupt encouraging the audience to cheer.*

Give them a round of applause! But most importantly boys and girls we have a huge cast of talented actors and actresses waiting in the wings just raring to start the show.

JOSH: Now I must explain…This all happened by accident boys and girls, you see the last time we did a pantomime here none of the actors turned up –

JOHN: – It was so frustrating because Josh didn't book them.

JOSH: Well it wasn't my job to book them –

JOHN: Had you of just booked them then we wouldn't have needed to do the whole show ourselves –

JOSH: – Well you could have booked them!

> JOSH *and* JOHN *begin to argue.*

JAMES: HEY HEY HEY GUYS! There will be no arguing here tonight!

> JOSH *and* JOHN *reluctantly nod in agreement.*

JAMES: But yes boys and girls Josh is right. Last year we did write a pantomime called *Cinderella and the Beanstalk* but none of the actors turned up. So we had to do the whole thing ourselves! All of the acting, singing, dancing and whilst you were a very kind and understanding audience it was a bit of a nightmare for us...it took years off us actually. Believe it or not, we are only fourteen years old.

> *Audience laugh as* **JAMES**, **JOSH** *and* **JOHN** *are clearly nearing thirty.*

JOSH: That shouldn't be that funny.

JAMES: But don't worry boys and girls because this year we have definitely booked a fantastic cast.

JOSH: That's right...Isn't it John.

JOHN: Yep that is correct...Isn't it Josh.

JOSH: ...Yes. That IS correct...Isn't it John!

JOHN: Yes Josh...A thirty-strong cast have been booked...Haven't they....

JOSH: Yes John...they were booked by...

JOSH & JOHN: YOU! ME? ...NO

JAMES: NOOOOOO! Why didn't you book the CAST! This can not have happened again. Nobody should have let this happen again. Sorry guys...I'm not doing a thirty man show on our own again. I won't do it...

> JOHN's *phone rings.*

JOSH: John is that you?

JAMES: Why have you got your phone on you? You know they don't allow phones in the theatre! Who is it?

JOHN: It's our agent...Yes it's Alice and I'm going to tell her exactly what Josh HASN'T DONE...AGAIN!

 Answers phone.

Hi Alice...What...I don't believe it...In here? This very room, right now? (**JOHN** *describes someone in the audience, getting more specific until the audience know exactly who he is referring to. e.g red jumper, beard, glasses.*) Yes. They're here. Boys...I need a word.

 They all go behind the curtain.

JOHN: Do you know who that is?

JAMES AND JOSH: NO.

JOHN: That is a Hollywood casting director.

JAMES AND JOSH: WHAT?!

JOHN: Looking to cast the LAST THREE ROLES of their new multi-million blockbuster PANTOMIME: THE MOVIE!

JAMES: You're kidding me! Wait a minute, three roles? There are three of us!

JOSH: But we're not actors James.

JAMES: It doesn't matter Josh! Think about it, if we do it ourselves this is our chance to make it big in Hollywood!

JOHN: But we haven't even got a musician.

JAMES: *(Head out of curtain.)* One second...Can anyone here play an instrument at all? Any instrument?

 BEN *raises his hand.*

JAMES: Anyone play guitar?

JAMES: Anyone play the piano?

JAMES: Anyone play the bassoon? Boom, would you mind coming down here for a second buddy? You can bring your coat that's fine.

JOHN: What's your name?

BEN: Ben...

JOHN: Ben?! That doesn't start with a J?!

BEN goes behind the curtain.

JAMES: Okay Ben, if you would like to just sit down here, all the music, all the instructions you need are right here in this folder. There you go, musician sorted.

They enter back in front of curtain.

JOHN: To be fair we do know the script, we know all the characters...

JAMES: See, John's on board!

JOSH: No! no no no. I'm not doing it. There's absolutely nothing you can say that will make me do it...

JAMES: You can be the giant lobster?

JOSH: ...I'm in.

JOSH and JAMES go behind the curtain.

JAMES: John, introduce the show!

JOHN: ALRIGHT! Ladies and Gentlemen, boys and girls, are you ready for *Scrooge & the Seven Dwarves*!

The curtains are pulled back to reveal the set of old Victorian London. JAMES, JOSH and JOHN give each other a look to say, I guess we're doing this.

SONG 1: CHRISTMAS SPIRIT

"Everyone is getting ready for Christmas,
All across Victorian London town.

Carol choirs sing on every corner,

The children are putting their stockings up over the fire.

Cos Christmas is coming tonight."

SCROOGE *is heard grumbling backstage.*

SCROOGE: Why are you not at work?

JOSH: We're children.

SCROOGE: Why are you not at school?

JOSH: It's the holidays

SCROOGE: Bah Humbug...

"In Santa's workshop everyone's ready for Christmas,

The sleigh is full, the presents are piled up high.

Elves are sweeping the floor and feeding the reindeer,

And Santa is watching it all with a happy smile.

Christmas is coming,

It's finally happening,

Everything's perfectly right,

Christmas is coming tonight."

SCENE 1: SANTA'S GROTTO

SANTA is holding his sack of presents in front of his sleigh ready to greet the audience.

JAMES: WOW! Ladies and gentleman. Please give it up for Ben from the Audience.

Audience applaud and **BEN** *grabs his coat to leave.*

Hey hey hey! You sit back down Ben. You've got plenty more songs to get through. Okay John...I mean 'Santa'.

SANTA: Ho ho hollo there boys and girls! How are you all doing today? Wonderful! I'm Father Christmas, it's Christmas Eve that is my favourite night of the year! Tell me what have you asked for for Christmas?

Audience member responds.

Really?! So you must be excited for Christmas...Are you all excited for Christmas?!

The audience cheer and the stage flashes with a bright red light.

Do you see that boys and girls? That was Christmas spirit, I use your Christmas spirit to power my sleigh you see! Come

on, stamp your feet, make some noise, show me how much Christmas spirit you have!

Audience go berserk. Lights go out. Crackle of Thunder is heard.

SANTA: What's going on?

WITCH: Looking for something St. Nick?

SANTA: W-w-who are you?!

WITCH: I am the wicked witch and I am pure evil.

BEN *encourages a BOO! from the audience.*

SANTA: Pure evil? Wait, what's that? Is that my Christmas spirit?!

WITCH: Yes I have stolen it all!

SANTA: Give it back!

WITCH: Evil zap!

Zap sound effect which throws **SANTA** *across the stage.*

SANTA: But why would you do something like that?

WITCH: Because Santa, when I was a little girl I asked you for a Nintendo Switch and you got me a satsuma!

SANTA: But they're delicious

WITCH: They're not! They're bitter and pithy. So now I have stolen all your Christmas spirit.

SANTA: You can't do that! I need it to power my sleigh.

WITCH: Exactly!

SANTA: But you'll ruin Christmas, if I can't fly my sleigh there won't be any presents for any of the boys and girl!

Points at a single girl in audience.

WITCH: Oh what a shame! Enjoy your Christmas Santa ha ha ha!

The **WITCH** *exits cackling.*

SANTA: Oh no boys and girls, what am I going to do?

SANTA *starts crying and* RUDOLPH *enters buzzing for another good year.*

RUDOLPH: Hey Santa, I was thinking Blitzen should ride up top with me this year if that's cool with you?

SANTA *runs off crying.*

RUDOLPH: What's wrong with Santa boys and girls? What?! A witch stole all of our Christmas spirit! Don't worry, Rudolph will help.

RUDOLPH *tries to start Santa's sleigh but it won't start.*

Oh it's no use, It's made of cardboard. MRS CLAUS!!!

MRS CLAUS *enters.*

MRS CLAUS: Rudolph what's wrong with Nicholas, I just saw him crying in the reindeer stable.

RUDOLPH: A witch turned up and stole all of the Christmas spirit!

MRS CLAUS: All of it?

RUDOLPH: Look around you!

MAMA CLAUS: Oh no.

The lights start to flicker.

MRS CLAUS: Well if she took all of it then what was that flicker?

RUDOLPH: Do I look like an electrician? I'm a reindeer man.

MRS CLAUS: There must still be a bit out there somewhere. Are you sure you collected Christmas spirit from everybody this year?

RUDOLPH: Yes. From absolutely everyone. Except... You know who.

MRS CLAUS: Voldemort?

RUDOLPH: No he loves Christmas!

MRS CLAUS: Oh you mean...

RUDOLPH: Don't say his name...

MRS CLAUS: I have to Rudolph, for the plot!

RUDOLPH: No.

MRS CLAUS: Yes.

RUDOLPH: No.

MRS CLAUS: Ebenezer Scrooge!

RUDOLPH: Not him! I want nothing to do with it!

> **RUDOLPH** *runs off stage.*

MRS CLAUS: Don't worry boys and girls, I've got a plan...It's off to Old Victorian London Town I go!

> **MRS CLAUS** *exits.*

SCENE 2 – SCROOGE'S OFFICE

SCROOGE *enters the stage.*

SCROOGE: I hate this time of year! It's far too cold and everyone –

> **SCROOGE** *notices the audience.*

What are you looking at? Do you know who I am? I'm Ebenezer Scrooge and apparently I'm the most miserable man in London BUT if you get to know me you'll find out very quickly that I'm actually THE MOST MISERABLE MAN IN THE WORLD! SO STOP LOOKING AT ME!

> **SCROOGE** *sits down in his chair and* **BOB CRACHIT** *enters.*

BOB: Mr Scrooge something very strange is happening in Old Victorian London town? The snow is melting, the Christmas trees are dying and the carollers can't remember any of the words to their Christmas carols –

SCROOGE: – Bob Crachit...What. Is. That?

> **BOB** *reveals a tiny wrapped present from behind his back.*

BOB: Oh this Mr Scrooge? This is just a tiny Christmas present for my tiny son, tiny Tim...It's a bike. Could you look after that please Ben?

> *Gives present to* **BEN.**

You see, He's become terribly unwell and every doctor in London is busy, you see there's been a major outbreak of tinselitus...

Audience sigh at the obvious joke.

It's pretty serious guys…People might die.

SCROOGE: Well if they're going to die they better do it, and decrease the surplus population.

BOB: Mr Scrooge, whilst you're felling so festive, I feel like this could be the time to talk to you about me having Christmas day…Off?

Super long silence. Long head turn towards **BOB**.

SCROOGE: Of course Bob.

BOB *is stunned. He takes a step to balance himself.*

BOB: Really Mr Scrooge?

SCROOGE: Yes Bob, you can have Christmas day off, and Boxing Day too…

BOB: Mr Scrooge that's so kind of you –

SCROOGE: – And the day after that, and the day after that, and the day after that, and you're so close to New Year's Eve, and New Year's Day off too…and the rest of January, February too, March, April, May, June, July, August, OCTOBER and when it starts to get cold again and winter rolls around you'll be able to have next Christmas off AND ALL OTHER DAYS BECAUSE YOU ARE FIRED!

BOB: Mr Scrooge please! You can't fire me –

SCROOGE: – Oh yes I can, because I'm the BOSS, you are just the BOB. NOW GET OUT!

BOB: Yes Mr Scrooge…

BOB *goes to leave. Audience awwwww.* **BOB** *encourages them to awww more.*

BOB: Too much. Oh and Mr Scrooge? One more thing. Merry Chr-

SCROOGE *holds a finger up which stops him. He points to the door which opens and* **BOB** *exits.* **SCROOGE** *blows his pointing finger out as if it's a gun.*

SCROOGE: Still got it.

SCROOGE *finds himself muttering about tiny things, a voice is heard from offstage waking him up with a startle.*

MRS CLAUS: *(Ghostly voice from offstage.)* EBENEZER SCROOGE!

SCROOGE: Hello? What was that?! Probably just an undigested bit of beef.

MRS CLAUS: *(Voice gets louder.)* EBENEZER SCROOGE!

SCROOGE: There it was again! Did you her that? Tell me you heard it

MRS CLAUS: *(Loud shrill voice.)* EBENEZER SCROOGE!

SCROOGE: Show yourself foul demon!

MAMA CLAUS *enters from the opposite exit that* **SCROOGE** *is looking at.*

MRS CLAUS: Ebenezer Scrooge?

SCROOGE: What? Who are you? Get out of my office at once or I shall call the authorities.

MRS CLAUS: No need for that my dear man, allow me to introduce myself, I am Mrs Claus.

SCROOGE: Mrs who?

MRS CLAUS: Claus, you know Santa Claus? Father Christmas? I'm his mother.

SCROOGE: Father Christmas? Right that's it, out now!

MRS CLAUS: Look just hear me out alright and then, if you still want me to leave, I'll leave okay? I promise.

SCROOGE: Fine, but make it quick, I'm cooking Turkey Twizzlers and I need to eat them all up before Jamie Oliver is born.

MRS CLAUS: Very well Scrooge, to cut a long story short, a Wicked Witch has stolen all of the Christmas Spirit so Santa can't deliver his presents to any of the boys and girls. This is where you come in. I believe there is still a tiny bit of Christmas spirit that she didn't get, buried deep inside of you!

SCROOGE: Nobody points at me!

Point fight. MRS CLAUS *wins.*

MAMA CLAUS: Scrooge I need you to unlock your festive spirit so you can save Christmas!

SCROOGE: But I hate Christmas.

MRS CLAUS: Yes, clearly, but I need you to see the magic in it again, come on surely you must have liked Christmas at some point?

SCROOGE: ...No I've always hated it.

MRS CLAUS: Alright, alright, I can see there's going to be no persuading you... Time for plan B.

MAMA CLAUS *uses fairy magic to take control of* SCROOGE.

SCROOGE: What on earth are you doing?! Put me down this instant!

MRS CLAUS: Sorry Scrooge I tried asking you nicely but if you don't find your Christmas spirit then Christmas is doomed! Have a nice trip!

SCROOGE *is blasted offstage. A* GHOST *enters.*

GHOST: Ooooooooh! Ebenezer Scrooge, I am the Ghost of Christmas past –

MRS CLAUS: – You're too late he's not here.

GHOST: Ahh man.

SECOND GHOST *enters.*

SECOND GHOST: Ebeneezer Scrooge...I'm the ghost of Christmas present –

GHOST: – He's not here

SECOND GHOST: – Oh...I'll tell the other one.

GHOSTS *exit.* SCROOGE *gets blasted on stage.*

SCROOGE: Mama Claus where are you sending me?

MAMA CLAUS: Ever heard of Fairytale land?

SCROOGE: Fairytale what?

MRS CLAUS: It's somewhere even you can't be miserable!

13

SCROOGE *doll comes down the stairs.*

MINI SCROOGE: Oh no. Oh no. I'm being sucked into this planet/ vortex thing. I'm loosing my hat.

SCENE 3 – FAIRYTALE LAND

After flying through the air **SCROOGE** *lands and looks around, he has no idea where he is, the place is colourful and bright.*

SCROOGE: Where on Earth am I?!

MAMA CLAUS: *(From offstage.)* This is Fairytale Land Scrooge. I'll leave you here to re-discover your Christmas spirit and I'll check in on you later dear okay!

SNOW WHITE: *(From offstage.)* Happy, Dopey, Grumpy, Bashful, Sneezy, Sleepy, Doc! Dwarves, where are my Dwarves.

SNOW WHITE *enters, audience laugh at the ridiculous outfit.*

JOSH: What did you expect? Obviously it's this.

SNOW WHITE: Hello there, have you seen my Dwarves?

SCROOGE: Dwarves? What are you talking about?

SNOW WHITE: My dwarves, they were right here? And then all of a sudden they vanished, into thin air! Where are my manners…My name is Snow White, and you must be, some sort of Troll?

SCROOGE: I am no Troll. My name is Ebenezer Scrooge and my patience is running thin!

MUNCHKIN: Did somebody say munchkin?

JAMES *enters the stage on his knees, dressed as a munchkin.*

MUNCHKIN: Yes. It is as offensive as it looks.

SCROOGE: I suppose that is one of your Dwarves?

SNOW WHITE: No no, that's not a Dwarf, that's a munchkin. They're one of the friendliest creatures in all of fairytale land.

SCROOGE: What…

MUNCHKIN: Hello my friend. Would you like a hug?

SCROOGE: Get out of my sight child! Before you regret it.

 MUNCHKIN *runs off crying.*

SNOW WHITE: You just made the Munchkin cry? Haven't you heard the rhyme. Every time a Munchkin cries a cat explodes.

SCROOGE: What? That is the most ridiculous I've ever –

 Cat explosion noise.

SCROOGE: Oh.

MUNCHKIN: I'm not going to cry any longer. I have been thinking about what you said and I have come to the conclusion that...I want to be your best friend! Come on, let's go and dance in the magical forest!

SCROOGE: There is no such thing as magical forests!

MUNCHKIN: There is here.

SCROOGE: And where are we?

MUNCHKIN: Fairytale Land of course

SCROOGE: And what is Fairytale land?

MUNCHKIN: Well...

SONG 4: WELCOME TO FAIRYTALE LAND

"Fairytale Land, Fairytale Land. It's a happy place,

Where you can meet, Your Fairytale friends."

SCROOGE: Stop this. If there's one thing I hate more than Christmas – it's singing and dancing! *(They gasp.)*

 SCROOGE *looks at the* **MUNCHKIN** *who is standing fully upright.* **JAMES** *clocks the audience and sinks back to his knees.*

SCROOGE: I just want to go home.

MUNCHKIN: Well where is home?

SCROOGE: Old Victorian London Town.

MUNCHKIN: There is one you person that could help you.

SCROOGE: Yes?

MUNCHKIN: Someone who knows all things.

SNOW WHITE: Stephen Fry?

MUNCHKIN: Close!

SCROOGE: Well! Who? Speak!

MUNCHKIN: The Great Wizard of OZ.

SCROOGE: Well how do you find this Wizard?

MUNCHKIN: He lives in the Emerald City at the end of this...well, what would you call it?

SNOW WHITE: Golden path?

MUNCHKIN: I'd say it was more of a blondish track.

SNOW WHITE: How about a sun-kissed right of way?

SCROOGE: It's clearly a yellow brick road! Now if you don't mind I'm off to see the Wizard.

SNOW WHITE: The wonderful Wizard?

SCROOGE: Of Oz yes!

 SCROOGE *exits.*

SNOW WHITE: Well if this Wizard knows everything he might know where my Dwarves are...

 SNOW WHITE *exits.*

MUNCHKIN: Now that's over I can get back to...What was I doing? Ah yes...Fairy Tales Land! Fairy Tale –

 SCROOGE *pokes his head in.*

SCROOGE: – SHUT UP!

 Sad violin plays. MUNCHKIN *cries and a cat explodes.*

JAMES: Meanwhile. Back in Old Victorian London Town.

SCENE 4 – BOB MEETS DWARVES

BOB *enters the office of* MR SCROOGE.

BOB: *(Whispering.)* Hello boys and girls! I know I was fired earlier but I've just come back to get Tiny Tim's present! I do hope

it makes him feel better. Mr Scrooge can't know I'm here so please don't tell him...

A loud crash is heard from backstage. A Dwarf rolls onto the stage. He gets up and looks bashfully at BOB.

BASHFUL: OOOOOOO!

BASHFUL *nervously runs off stage.*

BOB: Hello? Sorry little one I must admit I didn't see you there. Mr Scrooge doesn't like children –

GRUMPY: – We're not children, we're Dwarves!

SNEEZY: Grumpy put him down!

GRUMPY: NO!

SNEEZY: Right that's it...Doc!

JOHN *and* JAMES *both realise they will have to play all seven Dwarves.* JAMES *lets go of* JOSH *to run around and play* DOC.

DOC: What is it Sneezy?

SNEEZY: Who do you think, Grumpy.

DOC: Grumpy put him down!

GRUMPY: NO!

SNEEZY: Hey, don't you talk to Doc like that! I do apologise Sir. Grumpy, you leave me no choice.

SNEEZY *grabs his ear to pull him off* BOB.

Watch out Doc!

DOC: Woah woah woah.

SNEEZY: NO! He's too strong, help me!

DOC: I've got him what do I do?

SNEEZY: Chuck him!

SNEEZY *and* DOC *throw the imaginary* GRUMPY *into the audience.*

DOC: You alright Sneezy?

SNEEZY: I'm okay DOC!

BOB: Right! Could somebody please tell me what's going on?

17

DOC: Of course. Let's do this properly...DWARVES ASSEMBLE!

BOB: Hang on...I'm seeing double, seven dwarves!

SNEEZY: We are Seven Dwarves

BOB: Seven Dwarves? Well I am the one Bob Cracthit, pleased to meet you.

DOC: Pleasure to meet you Mr Cracthit, my name is Doc and this is my most handsome friend, Bashful.

BASHFUL: *(Completely taken back by DOCS words.)* Umm...Hi... I'm...It's...Well I...I'm the one who rolled in and hit the wall.

GRUMPY: I'm Grumpy. Get off my hand and Sleepy wake up!

> SLEEPY *raises his hand from the ground still asleep.* HAPPY *jumps on BOB's back.*

HAPPY: Go on...Have a guess?

BOB: Happy?

> *A Dwarf enters completely in a world of its own, his eyes tangled and tongue out.*

BOB: I think I'm getting the hang of this now, Dopey?

DOC: YES!

BOB: Okay...And what about you? You don't seem to have any prominent characteristics that I can make out. Who might you be?

DOC: This guy? It's Sneezy!

SNEEZY: Ah ah ah Hello.

BOB: Hello. Well I mean it's lovely to meet you all but what on earth are you all doing here?

DOC: Walk with me. It appears there has been some sort misconducto-travellisation between our world and yours.

SNEEZY: Yes one second we were walking down the yellow brick road in Fairytale Land with Snow White and the next thing we know bibbidty-bobbity-bang we're here!

DOC: Hang on, so if we travelled from Fairytale Land to Old Victorian London Town then something must have travelled from Old Victorian London Town to Fairytale land. As I recall

this has only happened once before when Humpty Dumpty the Egg switched places with Paul Hollywood.

SNEEZY: It must have been horrible in that *Bake Off* Tent! Watching all of his friends being beaten and whipped. He was never the same after that.

DOC: He didn't fall off that wall...He jum–

BOB: – Sorry, I'm not quite sure I follow? Anyway I don't watch *Bake Off* anymore – Mary Berry forever.

DOC: Yes, I may be the best doctor in all of fairytale land but even I can't fix that, that's more Sneezy's domain.

SNEEZY: I work for ITV.

BOB: Wait, hang on you're a doctor?

DOC: That's right! Doctor Doc. At your service.

BOB: Well that's splendid news. You see my son is feeling awfully sick and all the other doctors are busy, would you mind taking a look at him?

DOC: Of course Mr Cratchit...Bring in the patient!

> **BOB** *exits in a hurry.*

DOC: Give him a hand Sneezy

SNEEZY: Right you are

DOC: Oh and Sneezy! Make sure you're back for the song...

SNEEZY: Ah ah ah of course.

> **SNEEZY** *exits.* **BOB** *enters with the* **TINY TIM** *puppet.*

BOB: Here we are! My son, Tim.

DOC: AWWW. Hello there Tim, my name's Doc, I'm a doctor. It's an absolute pleasure to meet you, young man.

TIM: It's a pleasure to meet you too.

> **TIM** *starts to cough aggressively in* **DOC**'s *face.*

DOC: My word. Tim that quite a nasty case of the coughy-splutterkins you've got there, when did this come on?

TIM: Well…There I was, eagerly preparing for Christmas; the mince pies had been freshly baked, I was just about to lay out the last stocking on to the mantle piece…and then it hit me.

DOC: What hit you?

TIM: The mantle piece. It came right off its fixture onto my head and now I have the most terrible cold.

> **TIM** *coughs some more.*

DOC: I see…Would it be okay to have a quick look at Tim, Mr Crachit?

BOB: Oh, but of course.

DOC: Okay, just open your mouth for me there Tim. Uh huh. I see…Tim would you mind if I just cover your ears for a moment whilst I have a secret word with your daddy?

TIM: Okay!

DOC: Mr Crachit, Tim's sick.

BOB: No NO NOOOOOOOO!

DOC: I'm sorry to be the one to deliver this news Mr Crachit, please come back and be with your boy, he needs you now… more than ever!

BOB: Oh yes of course.

> *They play the too high, too low game.*

DOC: I'm afraid we need to examine him properly, Dwarves! Now Tim? Be a good boy and say ahhh

SONG 5: DOC'S EXAMINATION

"So the patient's name is Tim,
Shall we have a look at him,
It's true to say he is a little short.
And his chest is sounding wheezy,
He's bashful, he's sneezy,
He's practically one of us Dwarves!
Let's listen to his heart,
Its beat is off the charts,
Looks like we'll have to get some medicine.

You might be feeling ropey,
Bit sleepy, bit dopey.
We're gonna get you better Tiny Tim…
I couldn't Adam and Eve my old mince pies,
When I seen them tiny gnomes,
I've always hated being small,
And the other kids at school,
Would always leave me on my Jack Jones.
But look at these geezers,
Clever little bleeders,
No one could be better at all,
So maybe it's time,
To change me bacon rind,
Cos you can still be big even if you're small.
Yeah you can still be big even if you're small.
You can be big if you're small.
So, join the club little Timmy,
Sure you seem a bit skinny,
Tell me are you feeling any pain?
He's nervous and he's jumpy,
Well being ill can make you grumpy.
But rest assured,
The seven dwarves,
Will make you happy again."

BOB: So how can we help him Doc?

DOC: Well Mr Crachit, despite our jaunty number, there is absolutely nothing we can do for for your son…I'm afraid he needs specialist care.

BOB: But all the doctors are busy. There's no one who could help.

SNEEZY: Wait a minute where are we?

BOB: Old Victorian London Town.

SNEEZY: There may be one person who could help.

DOC: You can't mean.

SNEEZY: I do…

DOC: No, I can't see her. PLEASE!

SNEEZY: We can't just let Tiny Tim die Doc!

TIM *coughs.*

DOC: You're right, I guess I'm going to have to see her...

BOB: See who?

SNEEZY: MARY POPPINS!

> DOC *runs out crying.*

BOB: Sneezy, what's that about?

SNEEZY: You see Doc and Mary Poppins used to be in love. They opened a children's hospital together...Until she joined the private sector. I just hope seeing her again doesn't open old wounds.

BOB: Do you think it will?

SNEEZY: Ah ah AAHHHH

> SNEEZY *appears to sneeze but stops and casually walks off stage.*

BOB: Come on Tim, let's go

> As BOB *approaches offstage* SNEEZY *sneezes all over him.*

SCENE 6 – MIRROR MIRROR ON THE WALL

> WICKED WITCH *enters her lair cackling and holding the Christmas Spirit.*

WICKED WITCH: Look at it! Take it in, I have ALL of the Christmas Spirit! Oh boo all you like, I'm used to it! In fact, booing makes me stronger! Go on, boo me again!

> The WITCH *encourages the onslaught and makes Arnold Schwarzenegger poses as they continue.*

You see your boo's are like steroids to me! Yummy yummy steroids...Don't believe me? Ask my Magic Mirror.

> MIRROR MIRROR *enters.*

WICKED WITCH: Mirror, mirror on the wall, have I ruined Christmas for them all?

MIRROR: My queen, my mistress, with great regret, you haven't quite cancelled Christmas yet.

WICKED WITCH: But Mirror I have stolen all the Christmas Spirit?

MIRROR: Sadly there remains a tiny bit. Buried deep inside a man named Scrooge, he's so mean, he reminds me of you.

WICKED WITCH: Well where do I find this miserable man?

MIRROR: Mrs Claus has sent him to Fairytale Land.

MIRROR: Has she now, very well, put this in the safe my reflective stooge

She hands the **MIRROR** *the safe.*

MIRROR: Yes my mistress. I hope you find Mr Ebenezer. MUAHAHAHAHAHAAH

Magic **MIRROR** *slams into the wall attempting to exit the stage.*

WICKED WITCH: Very well so I shall travel to this Fairytale Land, find this Ebenezer Scrooge, and when I do I shall feed him a poisonous apple, putting him to sleep for a thousand years, just like I did with Snow White... Oh this place is filthy where is my broomstick? Ah here it is!

She pulls **JOSH** *onto the stage. He is dressed as a* **BROOMSTICK**.

BROOMSTICK: Hello, I'm a broomstick now!

WITCH: You brought my cauldron?

BROOMSTICK: Yes my Queen and this! Your handy witches spell-book. I've marked out the spell for poisonous fruit right here!

WITCH: And you're sure this is the right one?

BROOMSTICK: I'm absolutely positive! I'll get you a stand. Okay Ben you're going to have to wing it from now

BROOMSTICK *grabs* **BEN**'s *music sheets and flings them offstage placing the spell-book on the music stand.*

WITCH: Sorry Ben...Right here we go! Cauldron Cauldron smoke and bubble, fill my need to cause some trouble. A dangerous potion nice and thick, as I spiral round with my favourite stick. Splash and spew and squelch and plop! With every swirl snap, crackle and pop!

Suddenly a huge **DINOSAUR** *bursts into the theatre causing an uproar of chaos. It will interact with the audience. The* **WITCH** *does her best to get rid of the* **DINOSAUR** *until it has left from where it came.*

You stupid broomstick that wasn't the spell for poisonous fruit! That's the one that summons dinosaurs!

BROOMSTICK: Oh yeah, I see the problem here...I can't read.

WICKED WITCH: Get out! Now then where is the one I need.

The **WITCH** *walks over to the spell book, flips over to the next page and scrolls down the paper.*

Ah yes! Poisonous Fruit...Perfect!

The **WITCH** *assumes the position in front of the cauldron.*

Poisonous Fruitus! Oh that's it!

A lemon lifts magically out of the cauldron.

A Poisonous... Lemon? Okay I can work with that. Now clean up all this lemon rind will you?

BROOMSTICK: Oh I'd love to but I can't find the broomstick...Oh of course...HA! You couldn't write it! Right leave it with me, leave it with me.

BROOMSTICK *leaves.*

WITCH: Oh he's such an idiot isn't he boys and girls!

BROOMSTICK *returns with a broom.*

BROOMSTICK: It was in the cupboard.

WITCH: Right I need you to fetch every lemon in the castle.

BROOMSTICK: It'll be hard but I'll do my best.

WITCH: Oh and Broomstick, fetch my Old Hag costume will you?

BROOMSTICK: But you're already wearing...I will go and get the costume!

WITCH: You see boys and girls, I'm going to hide this poisonous lemon, in among the regular lemons, and as soon as Scrooge takes a bite, he falls asleep for a thousand years, and Christmas is ruined forever! Ha ha ha!

BROOMSTICK: Here you go my Queen one basket of lemons and one old hag costume.

WITCH: Great, I'll see you in a couple of days then. Right! It's off to Fairytale Land I go. MUAHAHAHAHA.

Transition with **WITCH** *coming down the staircase*

SCENE 8 – THE YELLOWISH PATH

WITCH: Right, here we are, Fairytale land.

SNOW WHITE: *(Off.)* Oh I just love it here in Fairytale land, we've got everything we need, sunshine, rainbows, there's a big Sainsbury's.

SCROOGE: *(Off.)* Bah Humbug.

WITCH: I must hide.

> **SCROOGE** *enters with an empty Sainsbury's bag.*

SCROOGE: Snow White won't stop following me and she won't shut up. I'm miles away from home and everyone keeps telling me I have to save Christmas. And I had to pay for this! I didn't even buy anything!

> **WITCH** *appears as the old hag with a basket full of lemons.*

WITCH: Lemon sir?

SCROOGE: No.

WITCH: What! Please won't you try one of my delicious lemons?

> *The* **WITCH** *picks out a black lemon.*

SCROOGE: You are joking.

WITCH: Erm... No.

SCROOGE: A lemon?

WITCH: Yes.

SCROOGE: A raw lemon?

WITCH: So you're saying I need to cook the lemon?

SCROOGE: NO! NOBODY EATS LEMONS!

25

WITCH: You know what they say... When life gives you lemons, have a delicious slice of lemon Mr Scrooge.

SCROOGE: How do you know my name?

WITCH: Lucky guess, Ebeneezer.

SCROOGE: Anyway that's not the phrase! The phrase is "when life gives you lemons, make lemonade!

WITCH: Lemonade? Why didn't you say...I have loads of lemonade just over here.

SCROOGE: If I come and try the lemonade will you please leave me alone?

WITCH: But of course, follow me...

> **WITCH** *drops the basket of lemons.*

SCROOGE: Don't you need your lemons to make the lemonade?

WITCH: No not those lemons, only this one...

> **WITCH** *hold the poison lemon in the air and cackles as the audience scream 'No' with* **BEN**. *She leads* **SCROOGE** *offstage. He stops and looks as if he is going to realise the situation.*

SCROOGE: Shut up, Ben.

> **SNOW WHITE** *enters,* **BEN** *tries to warn her.*

SNOW WHITE: Shut up Ben. Boys and girls where did Mr Scrooge go?

> *Audience shout.*

Thanks guys, off I go! HANG ON! Lemons? Boys and girls, do you know who this belongs to?

> *Audience say 'Witch'.*

The Wicked Witch? What's she doing with a basket of lemons?

> *The audience tell her.*

SNOW WHITE: Well I'm going to put a stop to that boys and girls! Here's what I'm going to do, I'm going to lure the Wicked Witch away from Scrooge, come and hide over in the audience with you, and then just pelt her with lemons. But I could use some help. Will you help me?

Hands out lemons.

SNOW WHITE: Right time to lure her out with some breadcrumbs, just like my friends Hansel and Gretel.

One slice of bread drops to stage.

SNOW WHITE: That will do.

WICKED WITCH: Is that bread I smell? A solitary granary sleece, now this goes against my better judgement but yoink!

SNOW WHITE: NOW!

Audience throw lemons.

WITCH: What's this! Not lemons!

SCROOGE enters, WITCH exits.

SCROOGE: What's going on?

SNOW WHITE: Scrooge, did you eat any of those lemons?

SCROOGE: No.

SNOW WHITE: We did it boys and girls?

SCROOGE: Why did you ask?

SNOW WHITE: Because the lemons were poisonous.

Looks at lemonade. Dramatic music. x2

SNOW WHITE: That's not lemonade is it?

SCROOGE takes a sip.

SCROOGE: It is!

SCROOGE passes out through lemonade power.

WITCH: HAHAHAHA! My plan has worked. Christmas is ruined forever!... Seeya.

Audience boo. WITCH exits.

SNOW WHITE: Noooooo

Phone rings. JOHN gets up.

JOHN: Hello? It's Hollywood!

JOSH: What's going on?!

JOHN: Oh really? You're joking! Oh that's brilliant thank you so much!

JOSH: Well?!

JOHN: They want us!

JOSH: They want us!

They celebrate. **JOSH** *turns to the* **CASTING DIRECTOR**.

JOSH: Thank you so so much, we're so pleased we impressed you, we won't let you down!

JOHN: There is one thing though, they only want us, they don't want James.

JOSH: Well, I can't say I'm surprised, I mean some of us are shining up here and James well, not so much.

JOHN: That's a good point actually, boys and girls can you do me a favour and not tell James till the end of the show, he's my friend and I want him to keep his dignity.

JAMES *enters dressed as the* **MUNCHKIN**

JOSH: Erm John, he's behind you.

JOHN: Oh no he isn't.

JOSH: Oh yes he is.

JOHN: Oh no he isn't.

JOSH: No seriously he is.

JOHN *turns and sees* **JAMES**.

JAMES: Hey guys. What's goin on? We've still got the last Scene? Munchkin's birthday party?

JOHN: Well, we've just heard from the guy from Hollywood and he wants us for the movie...

JAMES: What?! That's amazing, that's all we've ever wanted, we're going to be movie stars guys and live in Hollywood! I

knew all our hard work would pay off one day...My mum's gonna be so proud of me!

JOHN: Well when I said 'we' I meant me and Josh. They don't want you.

JAMES: Yes they do.

Long awkward pause.

JOSH: Oh no they don't.

JAMES: Oh yes they do.

JOSH: *(With audience.)* On no they don't.

JAMES: Oh yes they do.

JOSH: *(With audience.)* Oh no they don't.

JAMES: Why?!

JOHN: They are casting Dwayne Johnson instead...

JAMES: The Rock?

JOHN: Yes!

JOSH: He's an actor now. And we are all fine with that.

Phone rings.

JOHN: Oh it's them. Maybe it's good news. Hello? Yeah he's right here. Ohhhhh, that clears things up. He'll be so pleased.

JAMES: Well?

JOHN: We've got to go now, he said he's booked us a flight that leaves in two hours, if we're going to do this Josh we need to leave right now .

JOSH: Sorry man, we've gotta go, sorry everyone. We've got to take this opportunity.

JAMES: Guys! The show! Guys!

JOHN and JOSH exit and JAMES is left alone. He sits down and takes off his hat, he looks around at the empty stage.

Right then boys and girls, I guess I need to work out how to do the rest of this pantomime on my own. You think I can do it on my own? Don't worry there will be a second half, it will still

be just as brilliant, I hope. See you back here in say, fifteen minutes? Ben you're going to help me...

JAMES *grabs* BEN *and exits.*

META NARRATIVE 3

JAMES *enters dressed as* MRS CLAUS.

JAMES: Ladies and gentlemen, boys and girls, are you ready for Act Two of the pantomime!? Well then please welcome back to the stage James and his best friend in the whole wide world, Ben from the audience!

Audience cheer.

Come on Ben...

You hear BEN *say 'I feel silly' from offstage. He walks on dressed in a ridiculous outfit.*

Right so Act Two of the pantomime starts with a song that Mrs Claus is singing to her son, Santa, who's all sad because the Christmas spirit is gone. Ben do you think you could be Santa for me? Great, and play the accordion. Okay so Act Two, of the pantomime here we go...

Song 6: TILL THAT BIG BEN RINGS

Listen to me, my only son

Pull yourself together,

Keep your red coat on.

They say nothing's really over,

Till the fat lady sings,

And Christmas isn't over,

Till that Big Ben rings!

JAMES: Right I'm gonna need your help everyone. There's meant to be a bassist but he's gone so could you guys be the bass for me please.

Audience join in singing the bass line.

Great and clap along! Okay great! Here we go

'Listen to Mama
You know I'm right'

> JAMES *slowly stops singing whilst* BEN *gets really into it.* BEN *notices* JAMES *isn't singing and stops.*

JAMES: Sorry guys sorry, that was really good. Thanks for trying to help. But this second act, there's so much more guys, characters I can't play, songs I can't sing, I'll make sure you all get your money back alright. But I can't do the rest of this pantomime without John and Josh, I just can't.

> JAMES *goes to leave, bass is heard from offstage.*

JAMES: Ben stop.

BEN: It's not me.

JAMES: Holly if that's you –

> JOSH *comes on playing the bass,* JOHN *comes in playing ukelele.*

JAMES: – Josh? John? You're back!

JOSH: Oh yeah buddy!

"Listen to mama, You know I'm right.

You're Father Christmas,

And it's Christmas Night.

There's always hope son,

While there's still time,

You've got to keep believing,

Till you hear that midnight chime.

That big old bell,

Out on the Thames,

Till stroke of midnight,

It's not the end.

So don't you worry,

31

About a thing,

Christmas isn't over,

Till the big bell rings!

Christmas isn't over,

Till the big bell rings!

Yes there's still hope,

While there's still time,

Remember Christmas isn't over,

Till you hear old Big Ben chime!"

JAMES: You came back!

JOHN: We weren't going to get on the plane without you James!

JOSH: We couldn't leave you man, we came back for you.

JAMES: So wait, you're going to finish the show with me?

BOTH: Of course we are!

JAMES: WE'RE GOING TO FINISH THE PANTO BOYS AND GIRLS!

CHEER!

JOSH: Right I'm going to go get changed.

SCENE 1: THE MASTER-PLAN

JAMES: Right where are we. Oh right I was Mama Claus-one second please

> **JAMES** *spins and becomes* **MAMA CLAUS.**

MAMA CLAUS: Right, when was the last time we saw Ebeneezer Scrooge, he'd drunk the poison lemonade and fallen asleep for a thousand years, right, what can I do? Think Mrs Claus, think! I know! I could climb inside his dreams, go with it, and show him what's actually happening in Old Victorian London Town. YES! That's what I'll do, because that's the only logical thing to do! Stand back, this is advanced dream magic boys and girls. I'm about to enter Scrooge's dream, do not try this at home.

> MAMA CLAUS *hits the floor and is transported into his dreams.*

SCROOGE: Mrs Claus? What are you doing in my dreams?

MAMA CLAUS: No time to explain, you just need to pay attention.

> MAMA CLAUS *puts* SCROOGE's *hat on his head and they're transported to Old Victorian London Town.*

BOB: Tim?

SCROOGE: Bob Crachit?

MRS CLAUS: Quick let's go hide over there!

SCENE 2: SAVE TIM/SCROOGE

BOB: Tim? Tim? Boys and Girls has anyone seen my son? He looks like me but a puppet, a little puppet guy.

> BOB *turns around.* TIM *is on his back, audience shout 'he's behind you',* BOB *turns around and moves him to the front, audience shout.*

He's in front of you. He's in front of you? Doesn't work does it? Oh Tim there you are. How are you feeling?

> TIM *coughs.*

Tim, that doesn't sound very good. Come on Dwarves where are you?

SNEEZY: Bob Crachit...Doc's very, very nervous. He hasn't seen Mary since they last saw each other.

> DOC *enters.*

BOB: Doc, you look awful!

DOC: I'm fine! Which house is it?

> SNEEZY *points at the door.*

DOC: Okay! Okay! I can do it – here I go, I am ringing the bell and... On second thoughts maybe we don't have to bother Mary? I mean Tiny Tim's looking better already.

> TINY TIM *coughs and looks drastically ill.*

TINY TIM: SAVE ME!

TIM *acts dead.*

BOB: Alright Tim don't milk it...

SNEEZY: Right that's it...Doc

DOC: What?

SNEEZY: Wing the bell!

DOC: What was that?

SNEEZY: WING the bell...

> *Gets audience to chant 'WING THE BELL'.*

DOC: ALRIGHT, I'll wing...RING the bell.

SNEEZY: Do you want me to come with you?

DOC: No thank you, Sneezy, I have to do this on my own.

SNEEZY: No no I'm your best friend, I've been here the whole time.

DOC: I sure hope Mary is in. Sneezy.

> **JOHN** *gets the hint that he needs to go and play* **MARY**.

SNEEZY: Oh! What's that Grumpy?

> *He exits...*

DOC: Right I am ringing the bell.

> *He pushes the bell, A Spoonful of Sugar is played.*

MARY POPPINS: *(Offstage.)* Oh go away. I'm becoming rather flum-bustercated in all honesty.

DOC: That doesn't sound like Mary, perhaps she doesn't realise it's me, I know what I'll do! I shall use the secret knock that Mary and I used to use when we were in love. A complicated knock that truly encapsulated the ebb and flow of our forbidden love

> **DOC** *warms up his fingers and delivers one single knock.*

MARY POPPINS: *(Offstage.)* Doc?

> **DOC** *runs away from the door.* **MARY** *appears.*

DOC: Mary, you look different?

MARY POPPINS: So do you, have you grown?

DOC: No...

34

DOC *goes back down to his knees.*

MARY POPPINS: It's been so long…

> **DOC** *and* **MARY** *have an awkward moment where they talk over each other.*

BOB: Mrs Poppins, please help, my tiny boy is sick….

> **MARY** *screams.*

DOC: BOB! I do apologise Mary, some people just lack the inter-transen-duity to understand ones…mis-conductu-latory constrestions…

MARY POPPINS: It's doesn't take a genius to presumplify ones actauli-tornities.

DOC: Our deepest regret-apologies.

> **TIM** *has another coughing fit.*

MARY POPPINS: My word thats the worst case of the coughysplutterkins I've ever seen.

DOC: That's what I said. That's why we came to you Mary.

MARY POPPINS: I see.

> **MARY** *takes* **TIM** *off the hands of* **BOB**. *She is very aware it's a puppet.*

TINY TIM: Can you help me?

MARY POPPINS: I'd like to tell help you but I'm felling far too antagepresimolacknegatastical today…

TINY TIM: What's that?

MARY POPPINS: *(Sighs.)* I was hoping it wouldn't come to this.

Song 7: Antagepresimolacknegatastical

"Now and again you get feelings, that you can't describe.

And you can't find the words, so you keep all those feelings inside.

And when it's so hard to explain,

Sometimes it's much simpler to say.

35

I'm feeling antagepressimolacknegatastical now

I'm feeling antagepressimolacknegatastical now

TINY TIM: Everyone knows that the world, can be cold and unkind, and the sun may be shining,

But storm clouds still fill up your mind.

Then Doc the Dwarf turns up at my home, my heart says yes but my body says no.

ALL: You're feeling so antagepressimolacknegatastical now
Everything is so antagepressimolacknegatastical now

I know I'm just feeling supercali-fragile, a spoonful of sugar will put me back in the saddle.

I'm practically perfect in every way. But I'm feeling antagepressimolacknegatastical today."

DOC: Hang on, this isn't the Mary Poppins I know, how long have you been feeling like this?

MARY POPPINS: About an hour or so I suppose

BOB: An hour? Why that's when the snow starting melting!

TIM: That's when I started feeling sick!

DOC: That's when we arrived here in Old Victorian London!

BOB: That's it! This has all happened at once! It's like everyone's lost their festive cheer.

DOC: Their seasonal wonder.

TIM: Their Christmas spirit.

MARY POPPINS: That's it! Our Christmas Spirit, it's gone! That's what Tim needs and if we don't get it to him soon…

TIM *coughs some more…*

BOB: Right Doc, head out there and try and find some Christmas spirit, carollers, Christmas trees, anything that could help!

DOC: Right away Bob, Mary I suppose this is goodbye… Again

MARY POPPINS: Wait! Doc. You're forgetting something… Your hat.

DOC: Oh right thank you. *(Goes to leave again.)*

MARY POPPINS: Wait! You're forgetting something else! Me!

MARY *and* DOC *exit.*

DOC: Come on Mary, there are some people I'd like you to meet. Lads, this is Mary...

Off stage each Dwarf is heard saying hello to MARY *ending with* GRUMPY *shouting 'NICE HAT'.*

BOB: What a strange Christmas this is turning out to be.

TIM: Dad, is there much hope for me Dad? There's always hope at Christmas isn't there?

BOB: Oh Tim, I just hope that there is someone out there who has some Christmas spirit. And if there is, I just hope that they're listening to me right now.

SCROOGE *enters.*

SCROOGE: I am listening.

BOB: Anyone at all, listening to me, right now.

SCROOGE: I am listening Bob.

BOB: Literally anyone, listening to old Bob Crachit waxing lyrical about Christmas Spirit.

SCROOGE: I am listening Bob!

BOB: No, looks like we better go home Tim.

BOB *leaves and walks through* SCROOGE *in the style of a purposely bad theatre device.*

SCROOGE: Theatre...I'm listening to you Bob.

MAMA CLAUS *enters.*

MAMA CLAUS: He can't hear you Scrooge.

SCROOGE: I don't understand, am I dead?

MAMA CLAUS: No not dead Scrooge, not yet anyway, you're currently still asleep in Fairytale Land.

SCROOGE: So this is all just a nightmare?

MAMA CLAUS: I'm afraid not Scrooge, everything you just saw is actually happening back in Old Victorian London Town.

SCROOGE: You mean Tim's actually that sick?

MAMA CLAUS: I'm afraid so.

SCROOGE: I…I feel, different.

MRS CLAUS: That is your conscience Scrooge. Something you haven't felt in a long time. Have you?

SCROOGE: It's getting worse Mrs Claus. Tiny Tim. He needs someone to help him otherwise he might…Die.

MRS CLAUS: Well if he's going to die he better do it,

> **SCROOGE** *hides his face and says the next line whilst* **MRS CLAUS** *mimes it.*

'And decrease the surplus population…'

SCROOGE: How did you do that?

MAMA CLAUS: I'm actually quite good at impressions. I can do a good Sean Connery. The name's Bond, speed boats, speed boats…

SCROOGE: What are you doing!? We must save Tiny Tim.

MRS CLAUS: There's only one person who can help him now Scrooge.

SCROOGE: …Is it you?

MRS CLAUS: What? No, it's you. That's why I sent you to Fairytale Land. You're the one who still has some Christmas Spirit inside of you, you just need to find it.

SCROOGE: But I don't know how?!

MRS CLAUS: You just need to be good Scrooge. Now wake up Scrooge, you must wake up, wake up, wake up….

> *Wavy hands transitions.*

SCENE 3 – SCROOGE BECOMES GOOD

Back to fairytale land, **SNOW WHITE** *is kneeling by* **SCROOGE.**

SNOW WHITE: NOOOOOOOOOOO! Oh it's no use boys and girls, I've been screaming no for hours now, Mr Scrooge has drunk the poison lemonade and fallen asleep for a thousand years! Wait a minute, didn't this happen to me? Didn't I eat a

poisonous apple and fall asleep for 1000 years. How did I wake up...

AUDIENCE: KISS HIM!

SNOW WHITE: What?

AUDIENCE: KISS HIM!

SCROOGE: – I'M AWAKE!

SNOW WHITE: Scrooge! You're awake! Thank goodness!

SCROOGE: WAIT! What did you say?

SNOW WHITE: You're awake...

SCROOGE: No, the other bit?

SNOW WHITE: Scrooge?

SCROOGE: After that!

SNOW WHITE: Thank goodness?

SCROOGE: THAT'S IT! Goodness! I had a vision! London! Bob! Tim! Sick! Dwarves!

SNOW WHITE: My dwarves!? Are they alright?!

SCROOGE: They're fine, they're in Old Victorian London Town. We need to unlock the Christmas spirit that is inside of me in order to save Tiny Tim! But in order to do that I need to be good!

SNOW WHITE: Well that's a start right there! That's the first time you've thought about someone else other than yourself.

SCROOGE: I am! Is that it? Am I good now?

SNOW WHITE: Not quite, there's a little bit more to it than that.

SCROOGE: Well?

SNOW WHITE: I don't know, I've been good my entire life, I wouldn't know how to teach anyone.

 TIN MAN *enters.*

TIN MAN: Perhaps I can be of assistance!

SCROOGE: Some sort of funnell man.

TIN MAN: I'm actually a Tin Man, but I can see the confusion, I am wearing a funnel. And this is my son.

TIN MAN *reveals a large tin bucket.*

Tinny Tim.

SCROOGE: Why are you here?

TIN MAN: You see Scrooge I used to be like you, cold, unkind, heartless, but then I saw the light.

SCROOGE: Yes and how are you good?

TIN MAN: I'll answer that by singing an 80s inspired electro pop number! Hit the music!

SCROOGE: Oh no!, I take it back, I don't want to be good anymore, please, no more singing!

<u>SONG 8: IT'S GOOD TO BE GOOD</u>

"When you're walking down the street,

What you gonna do?

When your next door neighbour,

Offers something to you?

How about a mince pie?

Oh I hate mince pies

Try the pie scrooge!

Oh that's actually quite nice

Or perhaps an old neighbour

Says help me please

Because I need some decorations

For my christmas tree

Bah humbug.

You could say humbug,

You could turn away,

And you could stay lonely till your dying day.

Or you could open your heart,

And open your eyes and see,

Take it from me,

It feels good to be good!

It takes guts to be kind!

To think about somebody else,

Every once in a while.

You could try to be polite,

Make somebody smile,

You can make it feel like Christmas,

Every day of your life!

You gotta fight for the right to be nice!

I just don't know what to do

Can I be of any help?

Help! That's it but who?

What do you think Tinny Tim?

Tinny Tim! Tiny Tim! Bob Crachit! That's it!

I could try to help,

I could raise his pay,

I could get them big turkey,

On Christmas Day!

This is strange,

I think I'm starting to see,

It does feel good to be good!

Guitar Solo

It feels good to be kind!

I'm going to try to be polite,

Make everyone smile,

It's going to be like Christmas,

Every day of my life!

Yes I'm gonna fight for my right to be nice. x2"

SCROOGE: So that's it! I need to see what I can do to make other people happy.

SNOW WHITE: Now you've got it Scrooge!

TIN MAN: I'm very hot.

SCROOGE: Let's get to the Wizard now so he can send me back so I can save Tiny Tim and Christmas once for all!

TIN MAN: Looks like my work here is done

SNOW WHITE: I thought you were going to take us all the way to the Wizard?

TIN MAN: I said…My work here is done.

SNOW WHITE: Right you are, come on Scrooge.

META NARRATIVE 4

Just as **TIN MAN** *is about to leave the phone rings,* **JAMES** *turns around and picks it up.*

JAMES: Hello? No this is James speaking, sure I can take a message, okay, sure, they what? They missed their flights?! They told me they…Yes no problem, I'll let them know don't worry. Cheers, bye, bye… Right!

> **JAMES** *storms offstage.*

SCENE 4 – WITCH AND THE MIRROR

> **MIRROR** *enters.*

MIRROR: I suppose you want to know why they call me the Magic Mirror?

> **MIRROR** *does magic trick to audience member,* **JAMES** *enters wearing witch hat but not the full costume. He has clearly given up.*

MIRROR: My Queen, my mistress, you will not be amused. For I, the Magic Mirror have got some bad news.

WITCH: …

MIRROR: My Queen, my mistress, you will not be amused. For, I the Magic Mirror, have got some bad news.

Nothing.

MIRROR: What bad news you say? Scrooge is alive, safe and well, it seems he shook off your evil spell. And I know you're not going to want to hear it, but he's realised the value of his Christmas spirit. This new Ebenezer wears no frown, he wants to find the Wizard and return to Victorian London...City.

WITCH: London you say. Then I should follow him, shouldn't I? But how am I going to get there?

> **BROOMSTICK** *enters.*

BROOMSTICK: Astride me my Queen, your loyal broomstick.

WITCH: Ha! Loyal?!

BROOMSTICK: Yes of course, your loyal broomstick my Queen.

WITCH: I think I'll travel by plane this time.

BROOMSTICK: Really? Because I'm pretty sure witches travel by broomstick.

WITCH: What's the matter? Do you not think I am good enough to go on a plane? Do you not think I deserve a ticket on the plane?

BROOMSTICK: Erm, I made your favourite mixed nuts my Queen...for your journey...on me the broomstick?

WITCH: Well I don't want them because I'm going by plane.

BROOMSTICK: Are you sure you don't want them for a funny joke we came up with?

WITCH: No because I can order nuts on the plane, to go with my croque monsieur on the plane and my plastic cup of wine on the plane and and those tiny cheese flavoured crackers you get on the plane, that is of course unless I MISS THE FLIGHT.

JOSH: Now look James it's not what you think –

JOHN: – Yeah we really did want to come back.

JAMES: Oh yeah I bet you did! It didn't have anything to do with the fact you missed your plane to Hollywood.

JOSH: Look, James, just calm down.

JAMES: Oh I'm calm! I'm very calm!

JOHN: You're clearly not.

JAMES: I can't believe I actually thought you had come back for me.

JOHN: Look we did!

JOSH: Missing the plane just helped make up our mind that's all...

JAMES: Oh that's good to know Josh, it's just one thing after another with you two isn't it, you just don't respect me do you. You don't even take any of this seriously!

JOSH: We do take it seriously!

Snakes burst out of the nut box.

JOSH: That was probably the wrong time for that.

JAMES: Right that is it!

JAMES *and* **JOSH** *start to fight.*

JOHN: Stop stop jus stop! Take a look at yourselves

Fight continues with all three of them.

BEN: Enough! That is enough! THAT'S ENOUGH!!!

They all stop. They all sit.

BEN: Stop this and sit down. Look at yourselves. I'm your biggest fan! That's why I came here... On my own. I love you guys but not when you're fighting. We don't care about Hollywood or money. We care about you guys. We care about what you do best, writing a pantomime, forgetting to book a cast then having to do it all yourselves.

JOSH: We do do that.

JAMES: He's right...

JOHN: I'm sorry Ben. We all are –

BEN: – Don't apologise to me! Apologise to the audience.

ALL: SORRY AUDIENCE.

BEN: Now are we gonna finish the show? Because I really want to see how it ends. So tell me James, how does the Wicked Witch get to London?

JAMES: On the broomstick Ben, with her cat and the little can of nuts for a snakes on a broomstick gag...

JOSH: Ahhh they've already popped out, it's ruined.

JAMES: I'm sorry guys.

JOHN: No I'm sorry.

JOSH: We're sorry.

The Sleeping Trees hug.

JOSH: Right I'll go get into the costume!

JOSH runs off excited.

JOHN: Right Shall we finish the show? What's next Holly?

HOLLY: The giant lobster!

JOHN: Oh I don't think we've got time for that anymore actually, sorry guys.

JAMES: Josh, don't get into the lobster costume!

JOSH: *(Offstage.)* NOOOOOOOOOO!

JOHN: Haven't got time mate, after that?

HOLLY: It's the Wizard after that

JAMES: Wizard?

Audience shout 'Lobster!!'

JOHN: Right hands up for the Lobster? It's gonna have to be The Wizard.

SCENE 5 – THE WIZARD

SNOW WHITE: We made it Scrooge, Emerald City!

SCROOGE: What a journey it's been.

SNOW WHITE: I can't believe we got attacked by a giant lobster...

SCROOGE: Now all we have to do is find that wizard!

WIZARD: Who dares enter the chamber of the great Wizard of Auz?!

SCROOGE: I'm ever so sorry sir but I was sent here in a bid to change my ways, and I have, believe me, but now I want to go home back to Old Victorian London, so I can help my friend Bob and his Tiny son Tim.

WIZARD: Very well, then I will send you home Mr Scrooge.

SCROOGE: Yes! He said yes!

WIZARD: IF, you pass a final tist.

SCROOGE: A tist?

WIZARD: I want you to give up the thing you deem most important, the thing you care about more than anything in the world

SCROOGE: Just tell me Wizard!

WIZARD: Your money Scrooge.

SCROOGE: I... I...But I've worked hard my whole life for my money, my money is all I have!

> **SNOW WHITE** *coughs.*

Wait. I've got you, the beautiful Ms White, and Ben from the audience, and THE audience, you're my friends aren't you boys and girls?

> *They agree.*

Then take my money Wizard. Take it all. I will honour Christmas in my heart and keep it all the year. That's for the die hards.

> *A hand comes out of doorway, with a card machine.* **SCROOGE** *taps his card.*

MRS CLAUS: Oh I am proud of you Ebenezer.

SCROOGE: What? MRS CLAUS!?

> **MRS CLAUS** *enters.*

It was you all along?

MRS CLAUS: That's right, I knew you'd get there in the end, look at you, you're completely full of Christmas spirit.

SCROOGE: Wait there's no time. You must send be back now Mrs Claus.

MRS CLAUS: Your wish is my command.

 MRS CLAUS *sends* SCROOGE *off.*

SCROOGE: Oh this is actually quite fun now.

SNOW WHITE: Wait! Wait! What about me? What about my Dwarves?!

MRS CLAUS: Oh right your dwarves should be arriving back...

 Popping sounds.

MRS CLAUS: Now!

SNOW WHITE: My Dwarves my seven Dwarves!

MRS CLAUS: Actually there's only six, Doc decided to stay in Old Victorian London.

SNOW WHITE: Whatever for?

DOPEY: My dearest Snow...

SNOW WHITE: Dopey?

 Walks on the stage embodying Ross Kemp.

DOPEY: Alright. It seems that passion has taken hold of our beloved leader Doc. It can be said that him and Mary have found their happy ending. It's true love. So be bashful, as love knows no modesty. Be grumpy, for love finds everyone. Be sleepy, and love will fill your dreams... And if you have to sneeze... Sneeze, man. Accept yourself and love will accept you. For that, above all else, is the key to being happy...I've been Ross Kemp, goodnight.

 Everyone is stunned. **DOPEY** *leaves.*

SNOW WHITE: Right?

MRS CLAUS: Okay? Right Snow White, without Doc the dwarves are going to need a new leader so you will take care of them won't you.

SNOW WHITE: I'll do my best!

SNOW WHITE *leaves.*

MRS CLAUS: And I'll take care of London!

SCENE 6 – SCROOGE IS HOME

A magical crash of sound thunders on the stage. **SCROOGE** *enters.*

SCROOGE: I recognise these cobbled streets I'm back in Old Victorian London Town. Little boy – what day is it?

BEN: It's Christmas eve, ten minutes till Christmas, just look at the clock.

> **SCROOGE** *gestures to blank clock.* **TIM** *is heard coughing offstage.*

SCROOGE: Wait who's that?! It can't be…It is! It's Bob Crachet! I'm going to play a little Christmas trick on him.

> **SCROOGE** *hides in the audience.* **BOB** *enters.*

BOB: Don't worry Tim, we're almost there.

SCROOGE: And where do you think you're going?

BOB: Mr Scrooge –

SCROOGE: Out with it man, speak!

BOB: DWARVES! POPPINS! CHRISTMAS! AHHHHH…

SCROOGE: Dwarves? Poppins?… CHRISTMAS! There's only one thing to say to you, Bob.

BOB: You can't fire me twice.

> **BOB** *turns and goes to leave.*

SCROOGE: What I want to say is… Sorry.

SONG 9: SORRY

"You've had to put up with many long years of my misery.
You might be aware that I'm not highly skilled with apologies.
But if you let me, you'll never forgot how I changed my ways.
Cos I just want to ask to forgive me.
Is it too late now to say sorry?"

Cos I'm missing more than just your accountancy.
Is it too late to offer an apology?
I know my ways nearly cost your job,
Is it too late to say sorry Bob?
I'm sorry,
My deepest most sincere apologies,
Sorry,
Yes I know you might be sick to death,
I think you might be my BFF.
Is it too late to express my regretfulness.
Cos I'd miss you if you were not there in my office.
Is it too late to offer an apology,
I know my ways nearly cost your job,
Is it too late now to say sorry Bob?

BOB: I have no idea what's going on.

GHOST OF CHRISTMAS FUTURE: Happy Easter hahahaha.

SCROOGE: I'll tell you what's going on. I have the Christmas Spirit that Tim needs inside me. And all we need to do to get it is sing a Christmas Carol, isn't that right boys and girls?

They split the audience.

MRS CLAUS: Wait one second Scrooge, we can't sing a Christmas carol without... A Christmas Tree

MRS CLAUS looks at the person in the front row.

Would you like to come up here sir? Give him a round of applause boys and girls!

MRS CLAUS wraps tinsel round the gentleman and then the song 'Oh Christmas Tree' ensues, the audience all joining in. SCROOGE leaves.

MAMA CLAUS: Right one last bit, stamp your feet make some noise.

Audience makes loads of noise, SANTA enters.

SANTA: Just in the saint nick of time too! Thank you so much! Right, come on Mum we've got presents to deliver!

49

SANTA *and* MAMA CLAUS *exit.*

BOB: But wait, in all this commotion I've forgotten to ask the most important question of all. Tim! How are you feeling?!

TIM: It's Christmas!

SCROOGE: Did it work?!

BOB: It sure did Mr Scrooge! Tim is right as rain.

TIM: Thank you Mr Scrooge

SCROOGE *takes* TIM.

SCROOGE: You're welcome Tiny Tim, Merry Christmas.

TIM: God bless us every...

The WITCH *enters.*

WICKED WITCH: You think a Christmas carol is going to stop me!

SCROOGE: You're too late you Wicked Witch, Christmas is here!

WICKED WITCH: I may be too late to ruin Christmas for everyone else, but I'm not too late to ruin Christmas for you!

BOB: Tim's present! How could you!

SCROOGE: Why don't you pick on somebody your own size... Get her Bob!

WITCH: Oh that's it...EVIL ZA-!

TIM: Noooooo! It's okay Mr Scrooge, she can have my present. With the Christmas spirit back I've got everything I need, and if Mr Scrooge can change then anyone can.

SCROOGE: Cheers, Tim.

WICKED WITCH: I feel all strange inside, almost as if I'm melting, I'm melting, MELTING!

SCROOGE: Wicked Witch you are not melting, that's just the ooey, gooey, huggy, sticky, mushy, lovely, squishy, ishy feeling of love and happiness inside you.

WICKED WITCH: You're right, it feels great!

Sleigh bells are heard.

BOB: Do you hear that?! Look Tim, Santa, there he is! Let's get you home.

BOB *exits.* **MINI SANTA** *flies.*

SCROOGE: Quick boys and girls...WAVE!

SANTA: Ho ho ho! Merry Christmas everyone, don't think I've forgotten you Scrooge, I've got you exactly what you deserve.

> *A present drops from the rigging and* **SCROOGE** *catches it and opens it.*

SCROOGE: Nobody's ever got me a present before...A lump of coal... I've always wanted a lump of coal! This is the best Christmas ever! You know what Witchy...You're ALL RIGHT!

> **JOSH** *enters as a giant lobster.*

JOSH: I'M A GIANT LOBSTER!!

SONG 10 – FINALE

And now we sing the final song of this year's Pantomime

We thank you all for coming

And hope you've had a good time

You've laughed, you've cheered, you've been a tree

You've even thrown lemons.

And one last thing we ask of you is to sing a repeptitive song

Happy Christmas

Hap-happy Christmas

Happy Christmas Happy Christmas everyone

Just the kids!

Everybody!

Happy Christmas Happy Christmas Everyone.

CINDERELLA (JAMES): There's one more thing before we go away

There's something else that we all want to say

ALL: If you're up or down

Life's okay with your friends around

Ho ho ho Merry Christmas

If you're up or down

Life's okay with your friends around

Ho ho ho Merry Christmas

*SLOW CLAPS*k

If you're up or down

Life's okay with your friends around

Ho ho ho Merry Christmas

If you're up or down

Life's okay with your friends around

Ho ho ho Merry Christmas

If you're up or down

Life's okay with your friends around

Ho ho ho Merry Christmaaaaaaaaaaaaaaaas

JAMES: Ladies and gentlemen, thank you so so much we did it, we did an entire pantomime! Merry Christmas and Goodnight!

Bows etc.

The cast exit triumphantly.

END

CINDERELLA (JAMES): I know! Fairy Godmother, will you marry us?

FAIRY GODMOTHER (JOSH): I wish I could, but I'm not ordained.

CINDERELLA (JAMES): Oh dear...

FAIRY GODMOTHER (JOSH): But I know someone who is...

Bring an audience member up on stage to conduct the wedding ceremony

Will you come and marry these two young lovers? Don't worry, I'll tell you what to do. Just grab their hands here; that's it you're doing marvellously. Now repeat after me:

Do you Liam Aloysius Charming...

and you Cinderella Rockerfeller...

take each other...

in holy matrimony...

now and forevermore...

Now say I do...

CINDERELLA / CHARMING: I do.

FAIRY GODMOTHER (JOSH):
I now pronounce you man and wife.
You may now kiss the bride.

JAMES and JOHN kiss the 'Priest' on the cheek.

FAIRY GODMOTHER (JOSH): Big round of applause for our priest! Thank you so much, you were brilliant.

<u>SONG – LIFE'S OK (AS LONG AS YOU HAVE FRIENDS)</u>

MARK: Now is the end of our story

Cinders has won, she takes the glory

FAIRY GODMOTHER (JOSH): I got my man back from the sky

CHARMING (JOHN): I get to do my own DIY

RUMPLE (JOSH): Um. Release the prisoners!

BOYS: Go, go, GO.

Runaround.

MARK: Ladies and gentlemen, boys and girls, free at last, please welcome your favourite pantomime characters!

MARK announces each character, which the BOYS play in turn.

Robin Hood (JAMES)

The Wicked Witch (JOSH)

Ali Baba (JOHN)

Alice in Wonderland (JAMES)

Tweedledum (JOSH)

Tweedledee (JOHN)

The Three Bears (ALL)

Noddy (JAMES)

Wishee Washee (JOSH)

The Pied Piper (JOHN)

Buttons (JAMES)

The Pantomime Horse (JOSH)

The White Rabbit (JOHN)

Tim Henman (JAMES) – Come on Tim!

Mirror Mirror On The Wall (JOSH)

Simba (JOHN)

MARK: And finally... The Genie of the Lamp!

GENIE (JAMES): Hello! It's me from earlier! And as it's Christmas, I'm going to grant that birthday boy Prince Charming one last wish.

CHARMING (JOHN): I wish to marry my one true love, Cinderella: right here, right now.

GENIE (JAMES): Your wish is my command...

CHARMING (JOHN): Cinderella, there you are! What an interesting wedding dress.

MARK: I only tell people I'm a giant so they don't come snooping around my magical factory. Otherwise everyone would know what they're getting for Christmas and we wouldn't want that now would we?

CINDERELLA (JAMES): So there was never a giant at all?

MARK: No. JUST I.

CINDERELLA (JAMES): I do have one question though St Nick.

MARK: What's that?

CINDERELLA (JAMES): Why do you need the golden eggs?

MARK: Well you know what they say. You can't beat eggs.

CINDERELLA (JAMES): Well then I guess I'd better give you back your eggs!

RUMPLE (JOSH): Not so fast, you lot. You're coming with me, girlie, and bring my golden eggs with you. I've got a special cell in my pantomime prison just for you. There'll be no laughter and no more happiness this year, or any subsequent years! Mwahahahaha!

MARK: Ho ho hold it, Rumplestiltskin. If you leave now, you won't get your Christmas present.

RUMPLE (JOSH): Christmas present?

MARK: Well, yes. Everyone deserves a Christmas present. Who will be the proud owner of this Star Wars Lego set?

RUMPLE (JOSH): Is it the Death Star one?

MARK: It certainly is.

RUMPLE (JOSH): Gimme gimme gimme gimme gimme!

MARK: I'll only give it to you if you release Cinderella, give me back my golden eggs, and free every single character from your evil pantomime prison.

RUMPLE (JOSH): Every single one?

CINDERELLA (JAMES): Really? All of them?

CHARMING (JOHN): Right now?

MARK: Yup.

FAIRY GODMOTHER (JOSH): I don't suppose there was anyone else with you at all?

CINDERELLA (JAMES): Well…

Enter JACK.

JACK (JOHN): I'm home!

FAIRY GODMOTHER (JOSH): Jack?

JACK (JOHN): Janet?

JACK and FAIRY GODMOTHER *embrace.*

CINDERELLA (JAMES): Fairy Godmother we haven't got time for this! I'm afraid we've done something terrible. We've woken up the giant at the top of the Beanstalk and he's heading right for us!

FAIRY GODMOTHER (JOSH): A giant? Oh no! Get behind me everyone! I'll protect you. Somehow…

Everyone looks towards the USL entrance. Nobody appears. The BOYS *huddle together.*

JOSH: Somebody needs to play the giant. James, can you do it?

JAMES: I can't do it, I'm already playing the main character! John, can you play the giant?

JOHN: I'm already playing three characters in this scene! Josh, can you?

JOSH: Look at me! Look at me!

The BOYS *descend into bickering.* MARK *walks offstage and appears again as Santa.*

GIANT (MARK): There you are!

BOYS *realise and rejoice.*

BOYS: Mark!

The BOYS *return to their positions as* MARK *enters dressed as Father Christmas.*

MARK: Why does everyone keep running away from me?

JACK (JOHN): Please don't hurt us Mister Giant!

MARK: I'm not a giant, I'm Father Christmas!

BOYS: What?!

CLAP *CLAP* CLAP*

And stomp your feet

STAMP *STAMP* *STAMP*

And sing...

Magic beans magic beans beans!

End song.

CHARMING (JOHN): Thank you boys and girls! Now I can see my one true love again!

FAIRY GODMOTHER (JOSH): I think I can see Cinderella.

UGLY SISTER 1 (JOHN): Charming, this is your last chance. It's me or Cinderella.

CHARMING (JOHN): Well, Cinderella. Obviously.

UGLY SISTER 1 (JOHN): Right. Merlin! I take it back! The answer's yes!

CINDERELLA (JAMES): Look out below!

CHARMING (JOHN): It's Cinderella!

RUMPLE (JOSH): And she's got my eggs!

UGLY SISTER 2 (JOHN): And my... cow! That's quite like a horse.

FAIRY GODMOTHER (JOSH): Here she comes!

Enter **CINDERELLA**, *who falls conveniently into* **CHARMING**'s *arms.*

CHARMING (JOHN): Cinderella! I've been searching for you the whole pantomime.

CINDERELLA (JAMES): And I you. But Prince, there's no time for this, there is something I need to tell you –

COW (JOSH): – Incoming!

Enter **COW**.

Home at last.

UGLY SISTER 2 (JOHN): My cow!

COW (JOSH): Um hello?

UGLY SISTER 2 (JOHN): Come with me... Oh a baby! I'm going to call you Darren!

MERLIN (JAMES): Very good everyone.
We're nearly there, but we just need a little bit more funk.
Boys and girls, can get funky with us and help grow the beanstalk?
Just join in with me – here we go!

EVERYONE: Clap your hands
CLAP *CLAP* CLAP*
And stomp your feet
STAMP *STAMP* *STAMP*
And sing magic beans magic beans beans
Clap your hands
CLAP *CLAP* CLAP*
And stomp your feet
STAMP *STAMP* *STAMP*
And sing magic beans magic beans beans

> **JAMES** *gets beanstalk out.*

MERLIN (JAMES): Yes! It's working.
Clap your hands
CLAP *CLAP* CLAP*
And stomp your feet
STAMP *STAMP* *STAMP*
And sing magic beans magic beans beans
Clap your hands
CLAP *CLAP* CLAP*
And stomp your feet
STAMP *STAMP* *STAMP*
And sing magic beans magic beans beans
Clap your hands
CLAP *CLAP* CLAP*
And stomp your feet
STAMP *STAMP* *STAMP*
And sing magic beans magic beans beans

MERLIN (JAMES): One more time!

EVERYONE: Clap your hands

Oh magic beans magic beans magic beans
Gonna make that stalky fly stalky fly very high
Oh magic beans magic beans magic beans
Come on shake your thing
And grow that funky beanstalk to the sky

FAIRY GODMOTHER (JOSH): Merlin?

MERLIN (JAMES): Yes

FAIRY GODMOTHER (JOSH): Let me get this straight
If we bust some moves
Then the beans'll be great?

MERLIN (JAMES): Oh yes it's an ancient remedy
It's all about the bass
And a tip-top melody

CHARMING (JOHN): Merlin hi it's me Prince Charming
Concerned about my moves
One word: alarming

MERLIN (JAMES): Oh Princey it's all about the feeling
If you fully commit that stalk'll shoot through the ceiling!

RUMPLE (JOSH): Merlin while I've got you here
Can you wish you luck with my future career?

MERLIN (JAMES): Sure

UGLY SISTER 2 (JOHN): Merlin can you make me pretty?

MERLIN (JAMES): Certainly not.
But hey now, back to the beans:
Don't believe me just watch.
Don't believe me just watch.
Hey hey hey ow!

EVERYONE: Magic beans magic beans magic beans
Gonna make that stalky fly stalky fly very high
Oh magic beans magic beans magic beans
Come on shake your thing
And grow that funky beanstalk to the sky

MERLIN (JAMES): Did someone say 'experienced wizard'?

FAIRY GODMOTHER (JOSH): Great Merlin's beard! It's the great bearded Merlin!

MERLIN (JAMES): Fairy Godmother! I haven't seen you since we were made in the lab.

RUMPLE (JOSH): Merlin, thank goodness you're here. We're trying to grow a beanstalk but we've only got ordinary beans.

MERLIN (JAMES): Ordinary beans? Well, haven't you tried the Magical Beanie spell?

UGLY SISTER 2 (JOHN): The Magical Beanie spell?

RUMPLE (JOSH): The Magical Beanie spell?

UGLY SISTER 1 (JOHN): The Magical Beanie spell?

FAIRY GODMOTHER (JOSH): The Magical Beanie spell?

CHARMING (JOHN): Follow the yellow brick road? I mean the Magical Beanie spell?

MERLIN (JAMES): Yes, the Magical Beanie spell. It goes a little something like this...

<u>SONG – FUNKY BEANS (ALL)</u>

MERLIN (JAMES): Do you want some magic beans?

ALL: Yes!

MERLIN (JAMES): It's easier than it seems.

ALL: That's handy!

MERLIN (JAMES): If you want the answer
Give yourself a chance and
Follow me...
Oh yeah! You like that? I'm still hip
Oooooh Oooooh Oooooh Oooooh
Baked beans or a kidney or a runner bean
Broad bean black bean mung bean or a butter bean
Whoever they are be them small or chunky
Can all turn magic if you keep the rhythm funky

UGLY SISTERS *enter.*

CHARMING (JOHN): Oh no. Not these two again...

UGLY SISTER 1 (JOHN): Hello Prince Charming. Rumple.

RUMPLE (JOSH): Ugly Sister Number One.

UGLY SISTER 2 (JOHN): Rumple.

RUMPLE (JOSH): Angelica.

UGLY SISTER 2 (JOHN): Charming.

CHARMING (JOHN): Hello, how are you? Wait! Are you two following me?

UGLY SISTER 1 (JOHN): Yes. Now that Cinderella's gone up the beanstalk, we think you should marry me.

UGLY SISTER 2 (JOHN): And I get your horse.

CHARMING (JOHN): I don't have a horse. How many times do I have to tell you? That's once now.

UGLY SISTER 2 (JOHN): Oh. You said he'd have a horse...

UGLY SISTER 1 (JOHN): Never mind what he does and doesn't have.

RUMPLE (JOSH): I'd have my golden eggs by now if it wasn't for you two.

UGLY SISTER 1 (JOHN): You stay out of this Rumple. Cinderella is our business.

FAIRY GODMOTHER *appears.*

FAIRY GODMOTHER (JOSH): Actually, Cinderella is my business.

OOH AHH (GODMOTHA) SAY OOH AHH (GODMOTHA) Very nice boys and girls, and I'm here to stop you Rumple Stiltskin once and for all!

CHARMING (JOHN): But wait Fairy Godmother we need your help. We need you to make these beans magical.

FAIRY GODMOTHER (JOSH): Well I wish I could help you but bean magic is the hardest form of magic there is. Just above voodoo. For that you'd need an experienced wizard.

UGLY SISTER 2 (JOHN): Wait who's that coming out of the fog?

GIANT: *(Voiceover.)* I CAN SEE YOU!

JACK (JOHN): Quickly, hide!

GIANT: *(Voiceover.)* WHERE HAVE THEY GONE?!

COW (JOSH): It's working.

JACK (JOHN): Quick. Under the laser beams. Imagine that you're Tom Cruise. In *Jerry Maguire*. Through the swamp now. Don't get stuck in it! Now across the ravine. Use these stepping stones. Come on Cinderella.

CINDERELLA (JAMES): I'm wearing a heel!

JACK (JOHN): WATCH OUT!

> **ALADDIN** *flys overhead on his carpet.*

CINDERELLA (JAMES): NOT NOW ALADIN!

JACK (JOHN): Across this big mountain. We should be safe up here. On this ledge. At eye level with the Giant.

GIANT: *(Voiceover.)* AH THERE YOU ARE!

CINDERELLA (JAMES): Quickly! Out that way and back to the top of the beanstalk.

> *They exit and it the lights go up to* **CHARMING** *and* **RUMPLE** *playing the waiting game.*

SCENE 5: SANTA SAVES THE DAY

CHARMING (JOHN): Ah-oo ah-oo ah-oo ah-oo…

RUMPLE (JOSH): Will you shut up?!

CHARMING (JOHN): Hah! You lose.

RUMPLE (JOSH): You said beans!

CHARMING (JOHN): What? When?

RUMPLE (JOSH): You wished for beans, not magic beans. That's why the beanstalk's not growing!

CHARMING (JOHN): Thank goodness. I thought I was just a terrible gardener…

CINDERELLA *gets out of the box. As she does so,* JACK *creeps off SL.*

Right boys and girls, we've got a bit of a situation. Mister Cow is giving birth and I need your help. I'm going to divide you into two groups. Everyone on this side of the room, you're going to be group one and you are the doctors. Hands up doctors. I need you to welcome Mr Cow's calf into the world, so I need you to shout 'Baby Cow! Baby Cow'. You try. Yes, that's it. Perfect. Now everyone on this side of the room, you're group two and you're going to be the midwives. Hands up midwives. You're going to help Mr Cow, so I need you to shout 'Push and breathe! Push and breathe!' Can I hear that? Lovely. Now altogether. Here we go...

COW *gives birth.* CINDERELLA *catches the calf in her dress skirt.*

CINDERELLA (JAMES): Well done boys and girls! Thanks to you we've got a lovely newborn calf. Isn't she lovely? Shall we name him? Excuse me, what's your name? That is a wonderful name. Let's call the calf Darren. Jack! Cow's given birth! Jack? Jack!?

JACK (JOHN): Cinderella, I got the eggs!

CINDERELLA (JAMES): Jack?! You got the eggs without waking up the giant?

GIANT: *(Voiceover – MARK.)* WHERE IN THE BLUE HELL ARE MY EGGS?

JACK (JOHN): Oh you said don't wake him up?

GIANT: *(Voiceover.)* FEE FI FO FUM I SMELL THE BLOOD OF A BABY CALF CALLED DARREN.

ALL: RUN!

The chase ensues.

COW (JOSH): Wait, my baby!

CINDERELLA (JAMES): Wait, my eggs!

JACK (JOHN): Wait, my self respect...

ALL: THAT WAY!

SCENE 4: GIANT HOUSE

JACK, THE BIG BAD WOLF *and* COW *are hiding inside a box and poke out their heads.*

JACK (JOHN): The giant's bedroom.

COW (JOSH): Wow. Wait, who's that?

WOLF (JAMES): Don't tell Red Riding Hood I'm here. Please.

COW (JOSH): Where's Cinderella?

> WOLF *ducks down and* CINDERELLA *pops up.*

CINDERELLA (JAMES): I'm right here! Okay guys, we need to do this as quickly and as efficiently as possible. One peep out of us could cost us our lives.

JACK (JOHN): Got it.

COW (JOSH): Guys...

CINDERELLA (JAMES): Mister Cow are you ready?

COW (JOSH): I'm think I'm giving birth.

CINDERELLA (JAMES): Great, if you can just...WHAT?

COW (JOSH): A baby cow is trying to get out of me, right now.

CINDERELLA (JAMES): You're giving birth? You're joking Mister Cow!

COW (JOSH): Nope. No I'm not.

CINDERELLA (JAMES): I don't understand – you're a girl?

COW (JOSH): I did think it was weird you calling me Mr Cow.

CINDERELLA (JAMES): Oh goodness! What do we do?! What do we do?!

COW (JOSH): You haven't got any painkillers on you have you?

CINDERELLA (JAMES): No. I only have pain enhancers with me. Everything is going to be fine Cow! Just breathe! I'll get help!

HAPPY BIRTHDAY TO YOU
HAPPY BIRTHDAY PRINCE CHARMING
HAPPY BIRTHDAY TO YOU

GENIE (JAMES): Congratulations old boy. Second wish?

RUMPLE (JOSH): Okay Charming, forget about the Cinderella. We just need the eggs and the Death Star –

CHARMING (JOHN): Rumple, I wish you would just sit down and shut up for one moment.

RUMPLE (JOSH): I can't believe you've done this.

GENIE (JAMES): Your wish is my command. Now Charming you're down to your final wish. Make it a good one. What do you really need?

CHARMING (JOHN): Oh, I don't know. Rumple, what should I get for my last wish?

RUMPLE (JOSH): …

CHARMING (JOHN): How rude. What do I need? I'm all out of ideas. Boys and girls, what should I ask for?

Audience shout out ideas.

That's it boys and girls with beans we can grow a beanstalk and I can get Cinderella back. Genie, I wish for beans.

GENIE (JAMES): Beans eh? Your wish is my command… There are your beans.

CHARMING (JOHN): Thank you Genie.

GENIE (JAMES): Good luck with everything. Now give me back my house.

GENIE *exits.*

CHARMING (JOHN): See Rumple, now I'll just pop these in here and Cinderella will be back in no time at all. Now we play the waiting game. You do know how to play the waiting game don't you Rumple? You sit and wait, and I make the most annoying noise I can. Ah ooh Ah ooh…

They both sigh.

CHARMING (JOHN): Tea?

RUMPLE (JOSH): That's an interesting looking flask.

CHARMING (JOHN): That's what I thought when Aladdin gave it to me for my birthday. Oh, there's a scuff on it. I'll rub it. That's better...

The GENIE of the lamp appears on stage.

GENIE (JAMES): Twenty years! Twenty years I've been stuck in that lamp! Aladdin used to rub that lamp every single day. Look at me, I'm covered in burns from all the tea you kept putting inside it.

CHARMING (JOHN): Sorry, who are you?

GENIE (JAMES): Who am I?! Look at my hat! Look at my massive hat!! I'm a magical genie. You're supposed to be the Prince of a magical kingdom! For someone in charge you seem to have very little understanding of magic and fairytales. For example, look over there – an egg in trousers sitting on a wall...

CHARMING (JOHN): Well at least he'll be safe up there.

GENIE (JAMES): Are you kidding me?! And over there – a musical stranger leading vermin and small children into a cave.

CHARMING (JOHN): How sweet.

GENIE (JAMES): No it isn't – it's illegal! Even I know that and I'm a magical genie!

CHARMING (JOHN): Sorry, who are you?

GENIE (JAMES): I'm a magical genie and I will grant you three wishes. Now hurry up.

RUMPLE (JOSH): Charming this is brilliant! All we need to do is wish for my golden eggs and a Lego Death Star. You could even wish for Cinderella back –

CHARMING (JOHN): – Rumple you're definitely onto something... Genie, I wish it was my birthday every day.

GENIE (JAMES): Your wish is my command.

EVERYONE: HAPPY BIRTHDAY TO YOU

ALL: TEAMWORK

TEAMWORK IS GOOD

TEAMWORK

TEAMWORK IS GREAT

TEAMWORK IT'S GOOD IT'S GREAT

TEAMWORK

TEAMWORK IS GOOD

TEAMWORK

TEAMWORK IS GREAT

TEAMWORK IT'S GOOD IT'S GREAT

IT'S GOOD IT'S GREAT

IT'S GOOD IT'S GREAT

End song.

CINDERELLA (JAMES): Wow. That was breathtaking guys. After that, I'm ready to step into the unknown, face my fears and retrieve those golden eggs as a... teamwork. There's no time to lose. Come on.

> **CINDERELLA** *holds out her arm and* **JACK** *gives her his elbow and they exit.* **RUMPLE** *and* **CHARMING** *enter and cry:*

Let's find the Giant's castle!

SCENE 3: MAGIC LAMP

CHARMING *is holding* **RUMPLE** *up by the scruff of the neck.*

CHARMING (JOHN): Stiltskin this is all your fault!

RUMPLE (JOSH): My fault? Technically you were the one who cut down the beanstalk.

CHARMING (JOHN): I guess you're right, but there's no point playing the blame game.

> **CHARMING** *lets go of* **RUMPLE** *and the puppet drops to the ground.*

CHARMING (JOHN): I suppose you're right.

RUMPLE (JOSH): I'll never get my golden eggs.

CHARMING (JOHN): And I'll never see Cinderella again.

TEAMWORK
TEAMWORK IS GREAT
TEAMWORK IT'S GOOD IT'S GREAT

JACK (JOHN): Yeah, I like it! Do it again!

COW (JOSH): TEAMWORK
TEAMWORK IS GOOD
TEAMWORK
TEAMWORK IS GREAT
TEAMWORK IT'S GOOD IT'S GREAT

> **CINDERELLA** *sighs and goes for a cry in the corner.*

JACK (JOHN): I think it's working Mr Cow,
She seems nobler somehow,
The song was simple but impossibly good.
Let us sing it again to awaken the world
Let us sing it again for the girl...
Come on you Cow Man,
You bovine apprentice,
you four legged poet,
you linguistic tempest.
Sing it again against all of the odds
Sing it again to empower the Gods

JACK AND COW: TEAMWORK
TEAMWORK IS GOOD
TEAMWORK
TEAMWORK IS GREAT
TEAMWORK IT'S GOOD IT'S GREAT
EVERYONE
TEAMWORK
TEAMWORK IS GOOD
TEAMWORK
TEAMWORK IS GREAT
TEAMWORK IT'S GOOD IT'S GREAT

JACK (JOHN): Come on everybody sing it with us now!!

COW (JOSH): No no no. That's your answer for everything! Jack! We have to work as a team. Think of something completely different!

Mystic guitar music.

JACK (JOHN): Cow, sit down a moment.

COW (JOSH): Jack –

JACK (JOHN): Sit down Cow!!

<u>SONG – TEAMWORK (ALL)</u>

JACK (JOHN): Theres a story to behold
By my father I was told
I was a boy just eleven years old.
There was a girl in search of some golden eggs,
on a quest with a cow standing by.
and theres something about this situation right here,
Similarities you cannot deny.
(Huy de huy de huy)
I remember how it went,
Up a beanstalk she was sent,
She was a girl just eleven years old.
And her trusty cow friend would rouse up a tune,
so inspiring it could cure common cold.
So exalting this song was a light through the dark,
from this cow just eleven years old.
(Huy de huy de huy)
Don't you see Cow? It all comes from you.
Come on you Cow Man,
You bovine apprentice,
you four legged poet,
you linguistic tempest.
Sing us a song against all of the odds
Sing us a song to empower the Gods

COW (JOSH): TEAMWORK
TEAMWORK IS GOOD

COW (JOSH): Oh I forgive you Jack.

CINDERELLA (JAMES): Wait, Jack? THE Jack? The same Jack who climbed the beanstalk all those years ago to fetch the golden eggs?

JACK (JOHN): Yes I am that Jack, but...

CINDERELLA (JAMES): Oh, this is perfect! We can all go home together, you can bring the eggs, I can give them to Rumple Stiltskin and I can finally see the Prince again!

JACK (JOHN): No you don't understand, I don't have the eggs!

CINDERELLA (JAMES): Why not? You've been up here for ages.

JACK (JOHN): Well, you see, they're guarded by a giant!

CINDERELLA AND COW: A giant?!

JACK (JOHN): And he keeps them locked deep inside his enormous castle!

CINDERELLA AND COW: A castle?!

JACK (JOHN): And he sleeps with them every night under his pillow!

CINDERELLA AND COW: A pillow?!!!

COW (JOSH): Is it one of those memory foam ones?

JACK (JOHN): I don't know what memory foam is!

COW (JOSH): It's like a pillow and a sponge.

CINDERELLA (JAMES): Oh no, this is hopeless boys and girls. If Jack can't get the eggs, what hope do I have? I mean, I'm just a little girl and he's a... well, a nutcase. I'm never going to see the Prince ever again.

JACK (JOHN): Is she always this miserable?

COW (JOSH): Has been as long as I've known her. Jack, what are we gonna do?

JACK (JOHN): Let me think...

Mystic pan flute music.

JACK (JOHN): I've got it! I should sell the cow!

CINDERELLA (JAMES): I never thought I'd see it. So Mister Cow, do you think these clouds will hold our weight?

COW (JOSH): Only one way to find out. 1, 2, 3, let's jump off the top of the beanstalk and see if the clouds will hold our weight.

They both jump.

BOTH: THEY DO!

CINDERELLA (JAMES): Right Mister Cow, I think it's this way. No, maybe it's this way. No it's definitely this way... Oh Mister Cow, everything looks the same up here! It's just clouds and clouds for miles around! Don't you just wish you were back home Mister Cow, in a warm leather jacket, drinking a cold glass of milk and eating a nice juicy beef burger.

COW (JOSH): Remind me why I'm helping you again?

CINDERELLA (JAMES): There could be danger lurking round every corner!

COW (JOSH): Cinderelly, Cinderelly don't you think that if there was anything dangerous up here that the audience would have given us some sort of traditional pantomime warning?

'It's behind you' sequence, as JACK *creeps up on* COW *and* CINDERELLA. *Eventually they see him.*

CINDERELLA (JAMES): Oh boys and girls. That's just a crazyman with a net, nobody who owned a net could hurt us.

JACK *throws his net over* COW *and* CINDERELLA.

CINDERELLA (JAMES): Oh no Mister Cow, we're trapped inside the net! Help!

JACK (JOHN): Hahahahaha! I've done it! After eighty-five years I've finally caught my first meal. Jack! You've done it at last!

COW (JOSH): Hang on a minute... Jack?

JACK (JOHN): Cow? Get out of me net! Cow...Is it really you?

COW (JOSH): Is it really me?

JACK *and* COW *perform a complex handshake.*

JACK (JOHN): It is you! Oh Cow, I haven't seen you since I sold you for those three magic beans...Sorry by the way.

JOSH: You see!? It was a Dinosaur.

> *(Old men.)*

JAMES: Well anyway, it's over.

JOHN: That stalk's cut down forever.

JOSH: And now back to our

ALL: Unfulfilling *(Kids.)*

> Hardly thrilling *(Cockneys.)*
>
> Rumour milling *(Businessmen.)*
>
> Lives. *(Normal Voices.)*

JOHN: What are we going to do?

JAMES: Don't ask me. I'm just an inconsequential townsperson.

SCENE 2: JACK

JOSH *changes into* **FAIRY GODMOTHER**.

FAIRY GODMOTHER (JOSH): We are back boys and girls! OOH AHH (GODMOTHA) SAY OOH AHH (GODMOTHA)

> When we left our story, Cinderella was stuck at the top of the beanstalk. Will she make it down again? Will she find those golden eggs? Will she find Jack, my one true love? And will Dick Whittington ever get to London? We won't be covering that last one… Anyway, let's head up to the top of the beanstalk to rejoin Cinderella and the Cow. Oh…the Cow!

> **JOSH** *changes into* **COW** *and joins* **CINDERELLA** *at the top of the beanstalk.*

CINDERELLA (JAMES): Oh Mister Cow, I can't believe we made it all the way to the top of the beanstalk. You can see everything from up here! Look, there's Never Never Land.

COW (JOSH): And there's the cave of wonders!

CINDERELLA (JAMES): And look, over there! *(Insert town you are in.)*

COW (JOSH): Wow…

JAMES: That Cinderella!

JOHN: The Prince has lost his one true love.

ALL: This Christmas.

 (Women.)

JOHN: I wonder what's up there in the clouds...

JAMES: Do you think there is a shopping centre?

JOSH: Or is that where all the Dinosaurs went to?

ALL: Or the things you lose

JAMES: Like tissues

JOHN: Reading glasses

JOSH: Or old shoes.

ALL: That what's there in the clouds.

 (Spoken interlude.)

JOHN: Have you heard the news?

JOSH: Yes, the Wolf hasn't been seen in days.

JAMES: No, no that. Cinderella's stuck in the clouds!

 They gasp.

 (Arm-wrestling gangsters.)

JOSH: What about Jack

JAMES: Who never came back?

JOHN: No one's been up the beanstalk since.

 (Businessman in a sauna.)

JAMES: I bet he fell.

JOHN: No I think, he ran from his own wedding.

JOSH: Well I heard he was beamed up by a

ALL: Spaceship.

 (Girls at a slumber party.)

JOHN: Up in the clouds

JAMES: I once heard a noise.

audience were fantastic. Give yourself a massive round of applause. I tell you what, I'm back on board! Bring on Act Two!

JOHN: Hit it Mark!

Boys run offstage with props, JAMES *ditches coat*

&

bag, lights go down, boys come back on.

SONG – UP THERE IN THE CLOUDS (ALL)

JAMES: Extra extra! Read all about it!

JOHN: Oh my goodness.

JOSH: I don't believe it!

(Normal singing voice.)

JOHN: Cinders is stuck

JOSH: Up in the clouds,

JAMES: The Prince cut the beanstalk down.

(Cockney.)

JOHN: The evil Rumplestiltskin

JOSH: Is trying to imprison

JAMES: Every Panto character.

(Children.)

ALL: All this at Christmas?

(Businessmen.)

JAMES: Who will go help?

JOHN: Who will it be?

JOSH: Well I'm already late for work.

JOHN: See you later Paul.

(Old Men)

JAMES: Does no one even miss her?

JOSH AND JOHN: Who?

35

Jumps down and hides behind box.

JOSH: Hey, I know you. You live next door to me don't you? You can say hello to me when you see me. You don't have to be afraid.

> **JOHN** *steps onto back box.*

JOHN: This is my house. I have to defend it.

> *Gun action. Red hot door knob moment re-enacted.*

JOSH: Where are you, you little creep?

JOHN: I'm up here! Come and get me!

JOSH: Heads up!

> *Paint can hits head.*

I'll get him for you Marv!

> *Paint can hits head.*

JOHN: You guys give up, or are you thirsty for more?

> **KEVIN** *gets caught.*

JOSH: First thing I'm gonna do is bite off every one of these little fingers, one at a time.

> *Shovel hit x2.*

JOHN: Nice move leaving the water running. Now we know each and every single house you've hit.

JOSH: We're the Wet Bandits – don't you forget it!

JOSH: Kevin?

JOHN: Mum?

> *Audience shout 'Kevin! What did you do to my room?' and* **JOHN** *gasps.*

MARK: (Voiceover.) The end.

> *Lights up again.*

JOHN / JOSH: Yes!

> *As applause dies down,* **JAMES** *is the only one still clapping.*

JAMES: Guys what on earth was that? That was better than the film! I really appreciate the effort you all went to, and the

JOSH: Okay everyone, get ready. Go!

20th Century Fox mouth trumpets.

JOSH: *Home. Alone.* It's the week before Christmas, and in the McCallister house the entire family is getting ready to leave for their holiday in Paris tomorrow. Kevin, the McCallister's youngest son, is talking to his mother:

JOSH *and* **JOHN** *turn into* **KEVIN** *and* **MRS MCCALLISTER.**

Kevin, go pack your suitcase!

JOHN: Pack my suitcase?

Parents Sleeping.

JOHN / JOSH: We slept in! Come on everyone, up on your feet! Running to the plane! That's it!

The audience get up and run on the spot until **JOHN** *cuts the running.*

JOHN: I made my family disappear! Aaaaaaah!

JOSH: What else could we be forgetting?

JOHN & JOSH: Kevin!

JOHN: Guys, I'm eating junk food and watching rubbish!

JOSH: Pizza! Bing bong

JOHN: 1...2...10!

Audience shoot the imaginary machine gun.

Keep the change you filthy animal.

JOSH: He's only a kid Harry. We can take him.

KEVIN *is listening in.*

Crowbars up!

'Rocking around the Christmas Tree' starts to play. The audience get up and dance.

He's home alone. We'll come back around 9 o'clock!

JOHN: Gasp! 9 o'clock!

goes like this (*Demonstrates.*) Here we go: '1…2…10!' amazing! Great work! Kids having fun with their guns there!! And then feel free to join in with me when I say 'Keep the change you filthy animal', which is my favourite line in the film! Say it after me 'keep the change you filthy animal'. Sounds great, let's put it all together: 1…2…10 – gunfire – keep the change you filthy animal!' Awesome.

JOSH: And finally, you're going to have the final line in our film. Kevin's brother Buzz, who is always picking on Kevin, comes home to find that Kevin has trashed his bedroom. So Kevin and his mum have a big reunion hug, the music will be playing, it's a beautiful moment, and then Mark will stop the music and you'll hear this noise

> MARK *plays record scratch.*

When you hear that, we need you all to shout 'Kevin, what did you do to my room?'. Big climactic line so lots of energy. Let's practise…Brilliant, that's fantastic!! Spot on.

JOHN: I'll go and get the mince pies.

JOSH: Everyone remember? We slept in, running on the spot, one two ten, *machine gun*, "Keep the change you filthy animal" and 'Kevin, what did you do to my room?' Oh, and one more thing – when you hear 'Rocking Around the Christmas Tree', we need you to boogie along with us. Bust out your best Christmas moves with us. You'll know when we get there.

JOHN: Josh, James is coming!

JOSH: Places everyone!

> JAMES *enters in a coat, wearing a rucksack.*

JAMES: See you later guys.

JOHN: James, how long's *Home Alone*?

JAMES: What? I don't know…Two hours?

JOHN: Well we're going to do it for you, in its entirety in two minutes. Take these and sit down and after two minutes, if you still want to go home, you're free to leave.

JAMES: Okay, two minutes, but only because I've got the pies. After that, I'm out of here.

ACT TWO

SCENE 1: HOME ALONE

JOSH and JOHN enter the stage in a panic.

JOSH: Ladies and gentlemen, thank you for coming back.
We've tried to persuade James to stay and continue with the
pantomime, but he isn't budging. He remains totally set on
going home and watching the film *Home Alone* while eating
mince pies, so we've come up with one last ditch idea to try to
make him stay.

JOHN: We don't know if this is going to work, but we are going to
try and make our very own homemade *Home Alone* for James
right now. For anyone who hasn't seen the film, boy gets left
at home, burglars come to rob the house, boy beats burglars,
Christmas. Simple as that. But we can't do this alone boys and
girls – we desperately need your help. Can you help us, boys
and girls? Come on, boys and girls, I know we're asking a lot of
you, but if you don't help us now we won't be able to finish the
pantomime. WILL YOU HELP US BOYS AND GIRLS?!

JOSH: Thank you so much. We're going to do as much as we can
on stage, but there's a few moments where we need you to help
us. The first thing we need from you is to be Kevin's family
when they're running around trying to make their plane on
time because they've overslept. So when you hear John and me
say 'we slept in!', you need to jump up to your feet and start
running for the plane. So if everyone could get up on your feet.
We know you've only just sat down again and you're probably
still nursing your interval orange juices, but we really need
your help. That's it. Okay, let's have a practise; 'We slept in!'
that's it! Everyone running! Get to the plane on time, let's hear
those feet stamping! Fantastic.

JOHN: Secondly, remember that bit in the film when Kevin
convinces the pizza guy that there are gangsters in the house?
You're going to be the machine gun. So when I say '1...2...10'
I want you all to make a big machine gun. My machine gun

JAMES: I'll tell you what's not on Josh, any more of this pantomime. I'm out of here.

JAMES exits USL towards dressing room.

JOHN: What are we going to do?

JOSH: James, James...JAMES!

JOSH and JOHN scuttle off after JAMES.

MARK: Um, I think that's the interval.

End of ACT ONE

JAFAR (JAMES): Yes?

> CHARMING *blinds* JAFAR *with dust (as before) getting an child audience member to help him grab it this time.*

JAFAR (JAMES): Where are you getting all this sand?

CHARMING (JOHN): That's my dealer!

Point at the kid that helped get the sand.

Ha are you done now? Because I really am getting tired. One more and I think I might lose...

RUMPLE (JOSH): I don't suppose there's anyone else back there who wants to defend me? ... Dick Whittington?!

CHARMING (JOHN): London's that way, Dick!

DICK (JAMES): Thank you sir!

RUMPLE (JOSH): Thanks for the help, Dick.

CHARMING (JOHN): Now it's just you and me, little boy.

> CHARMING *swings his sword at* RUMPLE, *who dodges twice. Swing towards beanstalk. On the second time,* CHARMING *inadvertently cuts it down.*

CHARMING (JOHN): Noooooooooooooooooo...

> CHARMING *looks distraught.* FREEZE FRAME. FAIRY GODMOTHER *enters.*

FAIRY GODMOTHER (JOSH): Oh no boys and girls! Prince Charming has accidentally cut down the beanstalk, leaving Cinderella stranded up there! Will she ever make it back to her one true love? Will –

JAMES: – No. No. That's it. I'm done with this. Sorry guys but these people paid for a pantomime, not the three of us running around like nutters. I'm sorry boys and girls but it's Christmas time and at Christmas time, all I want to do is to sit on my sofa, eat mince pies and watch *Home Alone*, because that's what I do at Christmas, I'm sorry but I don't do this.

JOSH: But James you can't leave the audience on a cliffhanger like this, it's not on!

RUMPLE (JOSH): Oh no. My only weakness! Weapons in general! Guards, protect me!

KING RAT entrance with music.

KING RAT (JAMES): King rat, at your service.

SWORD FIGHT. Midway through, JAMES kicks JOHN on the bum.

JOHN: What was that?

JAMES: What?

JOHN: You kicked me in the bum. I'm trying to be cool and you kicked me in the bum?

JAMES: Yeah, so what?

SWORD FIGHT CONTINUES. PRINCE CHARMING grabs some fairy dust from the floor.

JOHN: Oh King Rat?

KING RAT (JAMES): Yes?

CHARMING blows the sand in his eyes.

Ah my eyes!!

CHARMING (JOHN): Is that all you've got? I really hope so, because I'm tired now.

RUMPLE (JOSH): Jafar, your time has come!

JAFAR enters.

CHARMING (JOHN): Ha you idiot you have no sword, how stupid.

JAFAR magics the sword out of the PRINCE's hand.

JAFAR (JAMES): Prepare yourself for some Arabian fights!

FIST FIGHT. CHARMING gets JAFAR in a handlock.

JAMES: John. John? Time out? You're really hurting my wrist.

JOHN stops. JAMES hits him in the groin.

JAFAR (JAMES): Ahahahahaha! Yes!

FIST FIGHT continues.

CHARMING (JOHN): Ooh Jafar.

Oh Lord I'm blue, as blue as the Danube.

I fell for a guy who climbed into the sky.

My Jack who never came back.

Oh Jack won't you come back?

Song ends.

TINKERBELL *enters. It is a Barbie doll with wings dangling from a string on a stick.*

FAIRY GODMOTHER (JOSH): Oh hello Tinkerbell? What's that? Rumplestiltskin's built an evil pantomime prison and is imprisoning all our favourite pantomime characters? Oh no! I must go and stop him at once! See you later, Bs and Gs.

CHARMING *enters as* **FAIRY BARBIE** *leaves.*

CHARMING (JOHN): Hello tiny flying girl. Hang on. Tiny girls can't fly... The day I'm having.

Whistling, **CHARMING** *moves towards towards the base of the beanstalk.*

Right. Time to cut down the beanstalk once and for all. Using my trusty friend, Excalibur. Plucked from the stone by King Arthur, bought by me on Ama-zon. This is for you, Cinderella.

RUMPLE (JOSH): Wait! What are you doing?

CHARMING (JOHN): I'm just cutting down the beanstalk to save my one true love. What's it to you, little boy?

RUMPLE (JOSH): I'm not a little boy.

CHARMING (JOHN): Oh yes you are.

RUMPLE (JOSH): Oh no I'm not.

CHARMING (JOHN): Oh yes you are.

RUMPLE (JOSH): Oh no I'm not.

CHARMING (JOHN): Oh yes you are.

RUMPLE (JOSH): I'm a sixty-three year old man! I'm Rumplestiltskin and I sent your true love up the beanstalk.

CHARMING (JOHN): You did what? Then prepare to die, Rumplestiltskin!

CINDERELLA (JAMES): Goodbye boys and girls, see you when we get home! Goodbye!

FAIRY GODMOTHER (JOSH): Goodbye Cinderella, goodbye...

Oh boys and girls, I've got a confession to make. There is another reason I want Cinderella to go up the beanstalk. Many years ago, a man named Jack climbed up the beanstalk and never came home. That Jack, he's my one true love, and since he left I've been all alone. I must know what happened to him...

SONG – FAIRY GODMOTHER BLUES (JOSH)

When will I find my own happy ending?
Woe, how I'm tired from all the stories I'm mending.
Is there a plan for this magic Gran?
Is there a man who will make my life sparkle?
I've dated before but no one that special.
The worst one of all the Tasmanian Devil.
Tried Peter Pan but wasn't a fan.
The Gingerbread Man was sweet but too needy.
Fairy Godmothers need love too.
Oh Lord I'm blue, as blue as the Danube.
I fell for a guy who climbed into the sky.
My Jack who never came back.
Down in the swamps the frogs I've been kissing
Not one is a prince – is there something I'm missing?
I dated a toad, the banter it flowed
But on the way home his driving was reckless.

MARK: Poop poop

FAIRY GODMOTHER (JOSH):
I hated his friends, the rat was annoying
The badger was rude and the mole was... racist
Jack was complete, I was swept off my feet
But he did retreat from my furry bosom
Fairy Godmothers need love too.

JAMES *runs on.*

Ah Cinderella. There you are, finally. I'm here to help you up the beanstalk.

CINDERELLA (JAMES): Oh Fairy Godmother, it's so good to see you again! But now I'm here at the base of the stalk, I'm not sure whether I want to climb up it, I mean look at it, it's too big and too horizontal.

FAIRY GODMOTHER (JOSH): Oh but Cinderella, you must climb the beanstalk and bring back whatever – or whoever – is up there. But don't worry, you won't be alone.

CINDERELLA (JAMES): You're going to come with me?

FAIRY GODMOTHER (JOSH): No, I have to stay here and collect children's teeth.

CINDERELLA (JAMES): I didn't know you were a tooth fairy...

FAIRY GODMOTHER (JOSH): What's a tooth fairy?

CINDERELLA (JAMES): Right, well if not you then who?

FAIRY GODMOTHER (JOSH): That cow over there in the distance will go with you.

CINDERELLA (JAMES): That cow? But he's miles away!

FAIRY GODMOTHER (JOSH): Yes I will have to be very accurate with this spell... 'Iggledy Piggledy, pickles and cumin, turn this cow into a talking cow that can help Cinderella.'

JOHN *enters with a cow onesie and forces it on* JOSH.

JOSH: What are you doing?

JOHN: You're playing the cow mate.

JOSH: I can't! I'm already the Fairy Godmother in this scene!

JOHN: You made me play both ugly sisters. Enjoy!

A smug JOHN *exits.*

COW (JOSH): All right? Going up the beanstalk are we? Okay, I'll come with.

CINDERELLA (JAMES): You first, Mr Cow.

COW (JOSH): Bang up for it! Goodbye, boys and girls!

My stick!

CHORUS (JOHN & JAMES): Nah-nah-nah
He's Rumplestiltskin and he's bad
So bad.

ALL: Evil evil evil evil yeah
Evil evil evil evil yeah
Evil evil evil evil yeah

RUMPLE (JOSH): I'm evil and I know it...

End song.

RUMPLE (JOSH): Get back to prison you two.

PETER PAN *cries.*

PINOCHIO (JAMES): Oh grow up Peter.

They exit.

RUMPLE (JOSH): Right. I'd better get off to the beanstalk the quickest way I know how...

RUMPLE *flaps his wings and flies off to the E.T. Music.*

SCENE 8: COW APPRENTICE

JOHN: James, come and do the beanstalk.

JAMES: Can you give me a hand?

JOHN: No I'm setting the stage.

JAMES *struggles to get the beanstalk set on his own as* **JOHN** *deliberates over positioning the tiny toy cow.* **JOHN** *leaves, passing* **JAMES.**

FAIRY GODMOTHER *enters.*

FAIRY GODMOTHER (JOSH): OOH AHH... Don't tell me you've forgotten, boys and girls. OOH AHH –

Audience say 'GODMATHA!'

I SAY OOH AHH -

Audience say 'GODMATHA!'

Lovely. Just lovely. Cinderella? Cinderella? Cinderella!

SONG – I'M EVIL AND I KNOW IT (JOSH)

RUMPLE (JOSH): I'm Evil and I know it, I'm evil and I know it,
Want to know how evil I am?
I stole Pinocchio and Peter Pan

CHORUS (JOHN & JAMES): Nah-nah-nah
He's Rumplestiltskin and he's bad
So bad.

RUMPLE (JOSH): Want to know how evil I be?
I pushed Tarzan right out of his tree

CHORUS (JOHN & JAMES): Nah-nah-nah nah-nah-nah-nah
He's Rumplestiltskin and he's bad
So bad.

RUMPLE (JOSH): Evil runs through my veins, with big cigars and
cheap champagne. Evil is my middle na-a-ame

CHORUS (JOHN & JAMES): Woo! Woo!

RUMPLE (JOSH): Want to know how evil I was?
I sent the tornado took Dorothy to Oz
Want to know how evil I are?
I killed Mufasa working with Scar
(Scar's a friend of mine. We meet on Thursdays)

CHORUS (JOHN & JAMES): Nah-nah-nah
He's Rumplestiltskin and he's bad
So bad.

RUMPLE (JOSH): Little miss Muffet sat on a tuffet, eating her
curds and whey.
Along came Rumple dressed as a spider and stole miss Muffet
away!
Old Mother Hubbard went to the cupboard to fetch her poor
doggie a bone,
Then out jumped Rumple with a big bloody axe, and now her
poor doggie's alone!
Jack be nimble, Jack be quick, Jack went too far and was hit
with a stick.

UGLY SISTER 1 (JOHN): She was just telling me about this funny joke…

UGLY SISTER 2 (JOHN): What joke?

UGLY SISTER 1 (JOHN): Shut up… What are you waiting for Prince, cut it down.

CHARMING (JOHN): You're right, there's no time to lose! Thank you gentlemen.

CHARMING runs off.

UGLY SISTER 1 (JOHN): Mwahahahahaha. He just called us men didn't he? Never mind, with Cinderella stuck at the top of the beanstalk, the Prince will be all MINE.

UGLY SISTER 2 (JOHN): I thought you said he would be ours!

UGLY SISTER 1 (JOHN): I'm not going to lie to you, he'll be mine.

UGLY SISTER 2 is clearly gutted.

But you can have his horse?

UGLY SISTER 2 is slowly won around.

UGLY SISTER 2 (JOHN): You know me so well…

UGLY SISTER 1 (JOHN): Come on, let's go get some crisps.

UGLY SISTER 2 (JOHN): Okay…

RUMPLE enters.

RUMPLE (JOSH): Mwahahahaha. I heard the whole thing. If Prince Charming thinks he's going to stop me then he is sorely mistaken. No one can stop me. And once I get those golden eggs I'll be rich as well as evil. And when I'm rich, I can finally buy the one thing I've always wanted, my own Lego Death Star! You want to know how evil I am? I've built a huge pantomime prison and I've been capturing all your favourite pantomime characters. I think I'll even throw Cinderella in there once she gets back. Because I hate laughter and I hate joy, and when I'm done there will be no more Pantomimes and no more happiness. Forever! Mwahahahaha.

Audience BOO.

Boo all you want I'm evil and I know it.

together! Now it will be dangerous, but at least you'll have each other…

RED (JOSH): Okay.

RED *leaves.* WOLF *turns to* CHARMING.

WOLF (JAMES): Prince Charming.

CHARMING (JOHN): Yes?

WOLF (JAMES): Please don't make me go in there with her alone.

CHARMING (JOHN): Why?

WOLF (JAMES): She's a psycho.

RED *creepily pokes her head onto the stage.*

RED (JOSH): Wolfie, come on… Ah ha-ha-ha-ha.

CHARMING (JOHN): He'll be fine. Wait a tick, I recognise that music. That's the two ugly sisters. Coming to talk to me… Prince Charming. I can't wait.

UGLY SISTER 1 (JOHN): Prince Charming, we meet at last!

CHARMING (JOHN): Sorry, I'm off to find my one true love.

UGLY SISTER 2 (JOHN): What, our sister, Cinderella?

CHARMING (JOHN): Cinderella, what a beautiful name!

UGLY SISTER 1 (JOHN): Well you could say that but we're here to tell you that she is so ashamed of deserting you at the ball that she now feels unworthy of you, and has gone to climb up the beanstalk never to return!

CHARMING (JOHN): The beanstalk?

UGLY SISTER 2 (JOHN): The beanstalk!

UGLY SISTER 1 (JOHN): Yes, the beanstalk, and the only way to stop her is to chop it down before she can climb it!

UGLY SISTER 1 *winks to* UGLY SISTER 2.

UGLY SISTER 1 (JOHN): MWAHAHAH

UGLY SISTER 2 (JOHN): HOHOHOHOH

CHARMING (JOHN): What's so funny?

GRUMPY (JOHN): It's down to you to decide…

BASHFUL (JOSH): Which of us is leading you astray.

CINDERELLA (JAMES): Am I allowed to have two questions?

BASHFUL (JOSH): No.

GRUMPY (JOHN): Yes.

GNOMES: Thank you good luck on your quest!

GNOMES / MARK: We are the Gnomes. Tricksy Gnomes…

CINDERELLA (JAMES): Wait! Please won't you help me? I don't Gnome where I'm going…

> BASHFUL *bursts out laughing.*

BASHFUL (JOSH): Oh That's good! I haven't heard that one before. You know what, the beanstalk's just down there. Just take a right at the gingerbread house. You can't miss it.

CINDERELLA (JAMES): Thank you little gnomes! Farewell.

> CINDERELLA *exits.*

GRUMPY (JOHN): What are you doing? Why did you tell her!?

BASHFUL (JOSH): Oh because I'm sick of this. I want to go back to the diamond mine with the others.

GRUMPY (JOHN): But my lungs, Bashful, my lungs…

BASHFUL (JOSH): Snow White looked after us, Grumpy.

GRUMPY (JOHN): You're right.

BASHFUL (JOSH): Come on, let's go Gnome.

GNOMES: Hi ho, hi ho, it's off to work we go…

> *The* GNOMES *exit.*

SCENE 7: SLIPPER HUNT

CHARMING *has rallied up his search party for the missing slipper.* RED-RIDING HOOD *has turned up and so has* THE BIG-BAD WOLF.

CHARMING (JOHN): Little Red Riding Hood, Big Bad Wolf, thank you for coming. I've brought you two here today to find my glass slipper. You are to head into the deep dark forest…

beanstalk, we can make sure she never gets back and then the Prince will be all ours.

UGLY SISTER 2 (JOHN): That's an evil plan.

UGLY SISTER 1 (JOHN): They don't call me Ugly Sister Number One for nothing. Mwahahahaha.

UGLY SISTER 2 (JOHN): Hoohoohoohoo.

UGLY SISTER 1 (JOHN): Come on. Let's go find the Prince.

The **UGLY SISTERS** *exits.*

SCENE 6: TRICKSY GNOMES

UGLY SISTERS *are about to leave, but* **JOSH** *whispers to him, gives him a dwarf hat.* **CINDERELLA** *enters.*

CINDERELLA (JAMES): Oh no boys and girls I'm lost. I'm sure the beanstalk was around here somewhere... Hello little friends, who are you?

SONG – TRICKSY GNOMES

GNOMES (JOSH & JOHN): We are the gnomes, Tricksy Gnomes.

CINDERELLA (JAMES): That's interesting. I've not heard of you before.

GNOMES / MARK: One tells the truth, one lies – which is which?

GNOMES (JOSH & JOHN): Who knows...

CINDERELLA (JAMES): Great, well Gnomes, can you help me? I'm looking for the beanstalk –

GRUMPY (JOHN): Hold on now.

BASHFUL (JOSH): Not so fast!

GRUMPY (JOHN): You may ask one question...

BASHFUL (JOSH): But you'll get two answers.

GRUMPY (JOHN): One of us will lie.

BASHFUL (JOSH): And one of us won't.

CINDERELLA (JAMES): My glass slipper?! But if you have it the Prince will never be able to find me again!

RUMPLE (JOSH): Exactly! He'll never be able to find you and make your wildest dreams come true, unless you climb the beanstalk in the middle of town, find the three golden eggs at the top of it and bring them back down to me! Or I will smash your slipper and all your hopes of happiness...Isn't that right boys and girls? Mwahahaha!

Audience BOO.

See, booing means yes!

CINDERELLA (JAMES): Hang on Mr Stiltskin, why can't I just write my address down on something else and get it to the Prince another way?

RUMPLE (JOSH): You can't, because I have eaten all the pens. Mwahahaha.

CINDERELLA (JAMES): You really have thought of everything. What do you think, boys and girls? Should I do what this crazyman says? You're probably right, I don't trust this tiny man and it does sound dangerous, but if I don't do it I might never see my one true love again. I'm sorry boys and girls. Little boy, I accept your quest.

RUMPLE (JOSH): Shake on it.

They shake hands.

CINDERELLA (JAMES): Ugh!

RUMPLE (JOSH): What? It's just sour cream.

CINDERELLA (JAMES): It's still cold...

RUMPLE (JOSH): So I guess I'll see you when you've got my golden eggs. Mwahahaha.

RUMPLE struggles to exit with his tiny legs.

CINDERELLA (JAMES): Right boys and girls, I better get myself off to the beanstalk! I'll see you all very soon, come on duvet.

CINDERELLA picks up the duvet and exits.

UGLY SISTER 1 (JOHN): So it appears Cinderella is the Prince's one true love. Well, now Rumplestiltskin has sent her up the

Oh come find me Prince and rescue my heart

> CINDERELLA *gets into bed.*

CINDERELLA (JAMES): Goodnight boys and girls.

> *(Snores.)*

> *End song.*

SCENE 5: BAD DREAM

CINDERELLA *is sleeping behind her duvet when she begins to have a dream.* GODMOTHER, PRINCE CHARMING *and* RUMPLE *hide behind the duvet and pop out for their lines.*

FAIRY GODMOTHER (JOSH): When you hear the bell, you will lose the spell, the spell, the spell...

CHARMING (JOHN): Will you marry me, marry me, marry me...

RUMPLE (JOSH): I'm in your room, your room, your room...

CHARMING (JOHN): You're not fourteen are you? Are you? Are you?...

RUMPLE (JOSH): No seriously, I'm in your room.

> CINDERELLA *wakes up. She throws off the duvet to reveal* RUMPLE. CINDERS *screams.*

CINDERELLA (JAMES): Ah! Who the jiff are you?

RUMPLE (JOSH): I'll only tell you if you guess my name.

CINDERELLA (JAMES): Okay... Um... Rumplestiltskin?

RUMPLE (JOSH): Yes. No one ever gets that first time.

CINDERELLA (JAMES): What are you doing in my room?

RUMPLE (JOSH): Doing what I always do...being evil! Tell me Cinderella, did you enjoy yourself at the ball tonight?

CINDERELLA (JAMES): I don't know what you're talking about small boy.

RUMPLE (JOSH): Don't lie to me girlie! I know you were at the ball, because I was there too, in disguise. And I have something very important to you... YOUR GLASS SLIPPER!

yet my teeth are my own,
starving abandoned and left all alone.
Oh I found a prince but where is he now,
Oh come back me prince and save me somehow.

UGLY SISTER 1 (JOHN): So I said...Catch of the day? More like get out of my car!

CINDERELLA (JAMES): When you're trying to sleep,
but there's little to eat,
and your stomach is nothing but rumbling
and your sisters are meanies
up there with martinis
and they're trying to talk but they're mumbling
so you whisk off away
to a happier day
when you're married, with kids, and on holiday
take a trip off to Spain,
by the beach with champagne
nothing special but nice for a getaway
then the fantasy's over,
crushed with a bulldozer,
get on with the jobs or get punished.
but there's nothing else left,
and your life is a mess
of just sweeping and dusting and rubbish.
I long for the day that I dance with my prince,
ooo my armpits they smell, better give them a rinse,
I've been dreaming and hoping,
had thoughts of eloping,
been wanting it now for so long.
Will he rescue me then?
God, I'm rambling again.
What's the point of this part of the song!?
Oh I found a Prince but where is he now?
Oh come back my Prince and save me somehow.
Oh I found a Prince who's handsome and smart,

CINDERELLA (JAMES): Yes just been here cleaning all night, just like you told me to.

UGLY SISTER 1 (JOHN): But wait a minute, you're all wet.

CINDERELLA (JAMES): I've been crying.

UGLY SISTER 1 (JOHN): Good.

CINDERELLA (JAMES): Where's my other ugly sister?

> *UGLY SISTER 1 morphs into UGLY SISTER 2 on the other side of* **CINDERELLA**.

UGLY SISTER 2 (JOHN): I'm right here!

CINDERELLA (JAMES): Sorry. I didn't see you there. Have a good night?

UGLY SISTER 2 (JOHN): It was alright actually, I drank three pints of custard.

CINDERELLA (JAMES): Great, anything else?

UGLY SISTER 2 (JOHN): Yes, the Prince found his one true love but then she mysteriously disappeared at the stroke of midnight.

CINDERELLA (JAMES): How odd.

UGLY SISTER 1 (JOHN): Never mind what happened at the ball! We're off to get our beauty sleep, not that we need it. Oh and Cinderella...

> **UGLY SISTER 1** *spits on the floor.*

You missed a spot... I just spat on it so you know where it is.

CINDERELLA (JAMES): Oh cheers.

UGLY SISTER 2 (JOHN): Night night, Cinderella.

CINDERELLA (JAMES): Goodnight. Sigh...

SONG – SAD CINDERS (JAMES)

Look at my clothes,
They're torn and in tatters
I'm locked in a basement with nothing but rat, ters.
Nothing to smile at,

BELLE *and* BEAST *are holding hands.*

CINDERELLA (JAMES): Hey Belle!

BELLE (JOHN): Hey!

CINDERELLA (JAMES): Hey BEAST!

BEAST (JOSH): MY NAME IS DAVID!

CINDERELLA (JAMES): Captain Hook?

HOOK (JOHN): Yes?

CINDERELLA (JAMES): It's me!

HOOK(JOHN): Smee? But Smee's right there.

SMEE (JOSH): Sir, how long do I have to pretend to be a crocodile?

HOOK(JOHN): Shut up, Smee.

CINDERELLA (JAMES): Oh I can see my house boys and girls! Just got to get across this Mermaid's Lagoon!

The Sleeping Trees go slow motion as they go underwater and then back to normal speed as they come up for air. CINDERELLA *sees an ugly duckling.*

UGLY DUCKLING (JOSH): Quack! Quack!

CINDERELLA (JAMES): Oh my god that duckling is so ugly.

The UGLY DUCKLING *looks gutted out to the audience.* CINDERELLA *finds* ARIEL *crying on a rock.*

Ariel, whatever's the matter?

ARIEL (JOHN): It's Prince Eric. He said I'd go well with chips. Get it. FISH & CHIPS!

JOSH: What now?

JOHN: Josh, Cinderella's bedroom. Grab the box!

SCENE 4: THERE'S NO PLACE LIKE HOME

CINDERELLA (JAMES): Home at last boys & girls!

UGLY SISTER 1 (JOHN): Cinderella! I hope you've had an awful evening?

The **PRINCE** *exits and* **CINDERELLA** *begins her pursuit to get back home in time.*

SCENE 3: INTO THE WOODS

CINDERELLA (JAMES): Oh no boys and girls. The mildly evil forest. I don't want to go in there, but if I don't I won't get home in time, I guess I don't have a choice...

Fallen tree/rolling man, **JOSH** *and* **JOHN** *roll upstage*

Oh no! A fallen tree! Oh no! A rolling man!

JOHN *and* **JOSH** *make bats with their hands and fly them into* **CINDERELLA**.

Ah! Hideous bats!

Aladdin's carpet, **JOHN** *and* **JOSH** *form a carpet with their arms and fly it over* **CINDERELLA**.

Aladdin, fly that carpet higher!!

JOHN *and* **JOSH** *make cobwebs with arms in front of* **CINDERELLA** *to climb through.*

Eurgh! Sticky cobwebs!

HANSEL *and* **GRETEL** *appear.*

Good evening Gretel!

GRETEL (JOHN): Good evening Cinderella!

CINDERELLA: Oh wait! Don't go to the candy house!

HANSEL (JOSH): There's a candy house!?

GRETEL & HANSEL: Let's go!

RAPUNZEL *jumps on the box.* **KNIGHT** *in shining armour is climbing up her hair.*

CINDERELLA (JAMES): Oh my goodness what long hair!

KNIGHT (JOSH): Coming Rapunzel!

RAPUNZEL (JOHN): Ow ow ow ow ow... Use the key use the key use the key!

Love is a Wickes brochure

CINDERELLA (JAMES): With you

CHARMING (JOHN): With you

BOTH: Like BnQ

Love is a Wickes brochure

End song.

CHARMING (JOHN): Can I say something crazy? Will you marry me?

CINDERELLA (JAMES): Can I say something even crazier?

CINDERELLA *makes a ridiculous face and then makes a noise.*

CHARMING (JOHN): Wow. That really was crazier. Can I take that as a yes?

CINDERELLA (JAMES): You may!

CINDERELLA (JAMES): Wait! Is that the time?

CHARMING (JOHN): Yes, one minute to midnight. What's the problem?

CINDERELLA (JAMES): Please Prince I have to leave right now. I don't have time to explain.

CHARMING (JOHN): Wait, you're not fourteen are you?

CINDERELLA (JAMES): Take this. It'll help you find me again.

CHARMING (JOHN): A glass slipper, how?!

CINDERELLA (JAMES): It's got my address written on the bottom of it.

CHARMING (JOHN): Clever girl.

CINDERELLA (JAMES): I know! Goodbye Prince!

CHARMING (JOHN): Goodbye, my bearded goddess!

BOTH: Out the blue

CINDERELLA (JAMES): Like BnQ

BOTH: It's nothing like I've ever seen before...
 Love is a Wickes Brochure
 Love is a Wickes Brochure
 Love is a Wickes Brochure.

CINDERELLA (JAMES): With you

CHARMING (JOHN): With you

BOTH: Like BnQ
 Love is a Wickes' Brochure...

CHARMING (JOHN): I mean it's crazy.

CINDERELLA (JAMES): What?

CHARMING (JOHN): We can finish each other's

CINDERELLA (JAMES): Shelving units

CHARMING (JOHN): That's what I was going to say

CINDERELLA (JAMES): I've never met someone

BOTH: Who thinks so much like me

CHARMING (JOHN): Other than the staff at BnQ...

BOTH: I've got to give my confession. If we share the same obsession

CHARMING (JOHN): You

CINDERELLA (JAMES): And I

CHARMING (JOHN): Could

CINDERELLA (JAMES): Just fix

BOTH: A house

CINDERELLA (JAMES): Say goodbye

CHARMING (JOHN): Say goodbye

BOTH: To your Sunday nights
 There's so much DIY to do now
 Love is a Wickes brochure
 Love is a Wickes brochure

CINDERELLA (JAMES): Yes it's all true.

CHARMING (JOHN): Gosh, I wish I could do my own cleaning and DIY, but I'm the Prince, AND everyone else does everything for me.

CINDERELLA (JAMES): If you lived with me Prince, I'd let you do all the DIY you wanted.

CHARMING (JOHN): You would? Well, if you lived with me, you'd never have to do anything you didn't want to do.

CINDERELLA (JAMES): But who would do all of the cleaning?

CHARMING (JOHN): I've got a Dyson

CINDERELLA (JAMES): What's a Dyson?

CHARMING (JOHN): I'll show you...Dyson!

The world's oldest man takes the longest time to come on stage.

DYSON: Yes your Majesty?

CHARMING (JOHN): That'll be all. I want spending some quality with this lady.

DYSON *walks slowly off stage.*

CINDERELLA (JAMES): Sounds perfect.

CHARMING (JOHN): Doesn't it just?

SONG – LOVE IS A WICKES BROCHURE (JOHN & JAMES)

CINDERELLA (JAMES): Okay, can I just, say something crazy?

CHARMING (JOHN): I love crazy!

CINDERELLA (JAMES): All my life has been a series of cleaning and chores and then suddenly, I bump into you?

CHARMING (JOHN): I was thinking the same thing! 'Cause I've been searching my whole life for a girl who likes floors, kitchen tiles, bathroom sealant it's so out of the blue,

CINDERELLA (JAMES): But with you!

CHARMING (JOHN): But with you!

UGLY SISTER 2 (JOHN): Ok…

CINDERELLA (JAMES): Phew! That was close!

UGLY SISTER 1 (JOHN): Who said that?

> **UGLY SISTER 1** *Comes back out mimicking a T-Rex.*

CINDERELLA (JAMES): Oh! Stay very quiet and very still boys and girls, her vision is based on movement

> **UGLY SISTER 1** *makes a dinosaur noise and leaves.*

Thanks boys and girls. Now then, where was I? Oh yes! Prince Charming! He should be here any second!

> **CHARMING** *enters DSL and sits down right next to* **CINDERELLA.**

CHARMING (JOHN): I hate these balls I throw. All I want is to sit and read quietly by myself with nobody else around me.

> *The* **PRINCE** *sits down cross legged reading his brochure.*

It's a tough life…

CINDERELLA (JAMES): Oh my god, it's the prince! Should I talk to him boys and girls? Should I say hello to him? Shh, be cool.

> **CINDERELLA** *sits down beside the* **PRINCE**

What's that you're reading, your Highness?

CHARMING (JOHN): Oh, this is just a Wickes Brochure. Someone of your high stature wouldn't understand literature like this.

CINDERELLA (JAMES): Well that's where you're wrong Prince, you see I'm not your average ball guest, I don't spend my days playing croquet or filling china pots with aromatic popourri. I actually spend most of my time cleaning and building furniture.

CHARMING (JOHN): You do your own DIY?

CINDERELLA (JAMES): Why yes I'm forced to, by my two ugly sisters

CHARMING (JOHN): What's it like?

> **CINDERELLA** *demonstrates.*

Just like in the pictures!

And we're having a fabulous time.

Welcome to the ball HOORAY!

Callooh Callay, Callooh Callay.

Welcome to the ball HOORAY!

And we're having a fabulous time...!!!!!

END SONG.

JOHN *and* JOSH *high five and exit the stage.*

CINDERELLA (JAMES): Hello boys and girls! My name is Cinderella, and I'm very excited this evening because I'm here at the Prince's ball. You see boys and girls, tonight Prince Charming will chose his princess, and I'm certain he is destined to be my one true love.

UGLY SISTER 1 (JOHN): *(From offstage.)* Charming? Where are you?

CINDERELLA (JAMES): Oh no, it's my two ugly sisters! I must hide. Please don't tell them where I am boys and girls!

The UGLY SISTER *enters.*

UGLY SISTER 1 (JOHN): Charming? Where are you?

JOHN *realises there no one is playing the other* UGLY SISTER *and it's their line.*

JOHN: Josh! Play the other ugly sister!

JOSH *pokes his head on from offstage.*

JOSH: I can't.

JOHN: Why not?

JOSH: I'm not ugly enough.

JOHN *must play* US2. *He transforms his body and face into a different ugly sister.*

UGLY SISTER 2 (JOHN): Oh can't we sit down? My back hurts.

UGLY SISTER 1 (JOHN): Shut up you! Anyway...No one told you to stand like that! We must find the Prince for WE will be the Prince's ONE true love. Come on, let's go look in the utility room.

I heard a fine contortionist,

I know coz I'm a journalist.

A woop dee dee, a princess he does need.

A woop dee doo, I hope he finds her soon.

 CLAP *CLAP*

A princess will be picked today,

Callooh Callay, Callooh Callay.

A princess will be picked today,

Today at the Prince's ball.

Who will he choose? Who will it be?

It could be me.

It could be me.

Who will he pick, he must be sure.

Today at the Prince's ball.

The gathering is growing,

The trumpeters are blowing

It has, it's started snowing...

The buffet is not to be missed,

The cakes are quite the tastiest,

The pastries are the pastri'est.

A woop dee dee, a Princess he does need.

A woop dee doo, I hope he finds her soooooooooon.

Welcome to the ball HOORAY!

Callooh Callay, Callooh Callay.

Welcome to the ball HOORAY!

Callooh, Callooh, Callay.

Ball looks great, ball looks fine

Charming is handsome and oh so divine

The food's a treat it smells sublime

move on we'll be fine. So ladies and gentlemen, children and all, welcome to our wonderful, pantomime ball...

> JOSH *and* JOHN *set themselves.*

JOHN: Right. Mark?

> JOHN *clears his throat.*

The Prince is having a ball today!

JOSH: The Prince is having a ball today?

> JAMES *enters in heels and a dress.* JOSH *and* JOHN *cannot contain themselves.*

JAMES: Are we actually doing this? The whole thing? Look at me! Look at these!

JOHN: You look great. Doesn't James look great, boys and girls?

MARK: Come on, James.

JAMES: Alright. For you guys, and for you Mark, I'll do it. Let's go!

SONG – THE PRINCE IS HAVING A BALL (ALL)

The Prince is having a ball today! The Prince is having a ball today?

The Prince is having a ball today! THE PRINCE IS HAVING A BALL!

Look left, look right, look up, look down, Excitement flies through the town.

The Prince is having a ball today, the Prince is having a ball.

Plus one's, plus two's, no one's to lose, out on a fabulous ball.

The hustle and bustle you can't move a muscle

And everyone's coming 'cept Paul.

What?

What a party he'll be throwing.

The drinks will all be flowing.

I hope it don't start snowing.

This prince he is the hansom'ist,

MARK: Come on James!

JAMES: WHO ARE YOU?!

MARK: ...I'm Mark the musician you hired.

JAMES: Yes, I know. Look, I'm sorry but it's an absolutely awful idea. I'm not doing it...

> JOHN *grabs and lifts* JAMES *and gradually drags him offstage.*
> JAMES *improvises rage.*

JOHN: Ladies and gentlemen, *Cinderella and the Beanstalk*, Act One Scene One!

SCENE 2: THE BALL

> JOSH *changes into the* FAIRY GODMOTHER *in front of the audience.*

FAIRY GODMOTHER (JOSH): Hello there boys and girls. I am the Fairy Godmother! And I will be looking after you during the show today. Like all fairy godmothers, I spread happiness and joy wherever I go. So here's some happiness for you, and here's some joy for you. Now because we're going to be such good friends, every time I come on the stage I want to be sure that you're still out there. So I will say to you, 'oo-ah', and I want you to reply with, 'godmatha'! let's try that – 'ooh ah'.

> *Audience reply* 'GODMATHA'.

I said 'ooh ah'.

> *Audience reply* 'GODMATHA'.

Very nice, one more time with feeling shall we?'ooh ah'.

> *Audience reply* 'GODMATHA'.

I said 'ooh ah'.

> *Audience reply* 'GODMATHA'.

Oh that's wonderful boys and girls. Right, time to get you all up to speed with our story! Cinderella is about to arrive at Prince Charming's magical ball, but she must return home before midnight because that's when the spell will wear off. That's just how magic works, you get a four hour window and you do what you can, if we could all just accept that now and

5

JAMES: There's nobody there, just more boxes, come and have a look!

> *JOHN and JOSH run onto the stage in a panic.*

JOSH: He's right! There's nobody there.

JAMES: John, where are the actors?

JOHN: Was I supposed to book them?

JOSH: I don't know, I haven't booked any.

JAMES: So hang on, hang on, are you both telling me that we've got no actors? Who's this guy then?

MARK: I'm Mark. I'm the musician you hired.

JOHN: Can you act?

> *MARK shakes his head.*

JAMES: Right we're going to have to cancel the show.

JOSH: We can't cancel the show!

JAMES: Well what else are going to do Josh?!

JOHN: I've got an idea...

> *JOHN gestures to the tech box for lights up.*

Ladies and gentlemen, there will be a pantomime tonight because WE are going to perform it ourselves!

JOSH: YES! That's a great idea.

JAMES: No no no, we can't perform the pantomime ourselves.

JOHN: Why not? We wrote the script, we know all the characters.

JAMES: It's irrelevant whether or not we know the script! It's too complicated. There are too many characters. Think about it! There are dances, fight scenes, big chorus numbers, I mean none of us can sing, none of us can dance, none of us can act!

JOHN: James, you can act. Yes, you can be the main part, you can play Cinderella...

JOSH: Yeah and we can play everyone else!

JOHN: Come on James.

JOSH: Come on James.

4

ACT ONE

SCENE 1: INTRODUCTION

JAMES, **JOSH** and **JOHN** *enter the stage, each fully dressed in a tuxedo, cheering and whooping.*

JAMES: Good evening ladies and gentlemen, boys and girls! Thank you so much for coming, how are you doing tonight are you well?! Wonderful. My name is James.

JOSH: My name is Josh.

JOHN: And my name is John.

JAMES: And welcome to the world premiere of our brand new pantomime, *Cinderella and the Beanstalk*. Now this pantomime, which we've spent months writing, is very special and very unique because we've crammed in as many of your favourite fairytale and pantomime characters as we could google. As a result, we have a forty-strong cast just waiting in the wings, ready to sing and dance their hearts out for you boys and girls.

JOHN: We're really excited – are you excited boys and girls? Boys and girls, we've spent months writing this! I SAID ARE YOU EXCITED BOYS AND GIRLS?!

Audience cheer.

JOSH: Ladies and gentlemen, boys and girls, without any further ado, we give you *Cinderella and the Beanstalk*!

The Sleeping Trees join the audience ready to watch the world premiere of the pantomime. The actors don't come out on their cue.

JAMES: I'll just give the actors a wave...

JAMES *runs on to the stage covering his face with his blazer jacket.*

Guys! That's the cue...Yes! The lights changed, that's okay, no problem! We'll try it again ... THERE'S NOBODY THERE!

JOHN & JOSH: WHAT?

3

Cinderella and the Beanstalk was first performed at Theatre503, Christmas 2014.

Writers:	John Woodburn, James Dunnell Smith, Joshua George Smith
Director:	Tom Attenborough
Musical Director and Composer:	Mark Newnham
Movement Director:	Polly Bennett
Performers:	John Woodburn, James Dunnell Smith, Joshua George Smith, Mark Newnham
Producer:	Alice Carter
Set and Costume Designer:	Simon Wells
Lighting Designer:	Ali Hunter
Production Manager:	Heather Doole
Stage Manager:	Alice Carter

CINDERELLA AND THE BEANSTALK

Sleeping Trees

Cinderella and The Beanstalk

Salamander Street

PLAYS